PICTURE THE GIRL

PICTURE THE GIRL

YOUNG WOMEN SPEAK THEIR MINDS

AUDREY SHEHYN

NEW YORK

Book design by Ruth Lee

Library of Congress Cataloging-in-Publication Data

Shehyn, Audrey.
 Picture the girl : young women speak their minds / Audrey Shehyn.
 p. cm.
 ISBN 0-7868-8567-X
 1. Teenage girls—United States—Case studies. 2. Teenage girls—United States—Pictorial works. I. Title.
 HQ798.S4644 2000
 305.235—dc21 99-059211

FIRST EDITION

10 9 8 7 6 5 4 3 2 1

acknowledgments

The openness and honesty of the incredible young women who agreed to participate in this project provides great insight into the lives of teenage girls. They offered their stories to me, and in turn to all of us, with grace, determination, and purpose. I thank each and every one. I also want to thank the parents for allowing their daughters to participate.

None of this would have been possible without help from the following people who provided me with access: Dick Drew of Crystal Springs Uplands School; Jim Patterson, the principal of Tomales High School, and Ellen Webster and Sarah Morris for selecting an amazing group of girls for me to interview; John McCarty and Mary Isham at Mission High School; Binta Leighton, Eric Wilson, and Shelley Bradford-Bell at Bayview Opera House; Mimi Fruehan and Tina Kreitz from Island High School; and Trena Noval for pointing me in the right direction. Their trust allowed me to embark on a journey that has been challenging, rewarding, and sweet. I thank them all immensely.

Thanks to Leigh Saffold and Rachel Levin, my tireless and dedicated interns, who transcribed hours of tape, read every single version of every single excerpt, helped with editing, and kept me sane and on track.

Special thanks to my beloved friend Josh Peterson, who initially helped shape the direction of the project and who offered his invaluable feedback throughout the process.

Thanks to my generous and talented friends who shared their skills in editing the manuscript and photographs and who helped in many other ways: Jennifer Blake, David Collier, Luis Delgado, Amy Douglas, Marc Escobosa, Sarah Fawcett, Jason Grow, David Halliwill, Anne Hamersky, Ed Kashi, David Lenoue, Ellen McGarrahan, Evan Nisselson, Rebecca Paoletti, Elizabeth Quadros, Diana Smith, Leslie Svanevik, Laurie Wagner, and Annie Wells. Their faith in me and this work was essential to its success.

Laurie Fox of the Linda Chester Literary Agency is my hero. I thank her for recognizing the value of these stories. Thanks to David Cashion at Hyperion for taking on the book, and to my wonderful editor Alison Lowenstein, whose enthusiasm about the project was rivaled only by my own. Thanks to everyone at Hyperion who helped bring this book to life.

Thanks to Michael and Nancy for always welcoming me into their home, whether it was to celebrate the highs with a bottle of champagne or comfort me through the lows with chocolate ice cream. And so many thanks go to my dear, sweet Russ who makes me laugh at all the right moments!

Finally, I want to thank my family for surviving my teenage years, teaching me to ask many questions in life, and loving me.

PICTURE THE GIRL

introduction

At fourteen, I was awkward, weird, and confused. The big issues in my life were: wearing the wrong dress to school, loving a boy who didn't even know I existed, and feeling that everybody hated me. At that age, everything had enormous implications. In my early twenties, I eagerly embraced adulthood and left that confused girl behind.

More than a decade later, my teenage self reemerged when I began teaching photography at a suburban high school. The concerns of the young women around me were at once strange and familiar. I sensed that girls were facing the same issues I continued to struggle with as a thirty-year-old woman. My own voice echoed in their sentiments: "Who am I? Will I succeed in life? Will I be popular, or simply accepted? Am I thin enough, smart enough, good enough?" It surprised me to find this adolescent angst so firmly rooted in my own adult identity. I wanted to better understand what had transpired in those difficult years, and why so many of the fears and worries of that time still affected me.

Watching these young women navigate their lives proved fascinating. Teenagers can come off as so strong, so knowing, but in truth they are incredibly vulnerable because a whole new world is opening up to them. They are experiencing freedom they have never tasted before, a novel independence, and with it comes fear, as well as responsibility. I saw myself in these girls and yet many differences existed between us. The varied opportunities I had encountered as a girl are now expectations. When I was growing up, girls were still receiving the benefits of the feminist movement. We felt lucky and excited about having a career or becoming a mother, but we weren't necessarily expected to do everything. Young women today confront incredible challenges; they feel compelled to be and do it all.

This book comes out of a desire to give voice to those individuals who are immersed in the fragile process of becoming adults. I wanted to know what they were thinking. And being a photographer, I also wanted to make an image that captured each girl's essence. The differences between how people present themselves to others and how they see themselves have always intrigued me— and teenage girls are full of beautiful, innocent contradictions. When photographing each girl I asked her not only to be herself, but to be explicitly herself: to project her character onto the film, to use her body language or expression to say, "This is who I am."

That is what I wanted to know: "Who are you? Who is the person behind this trendy, moody, teenage guise?" What I discovered is an astute and inspiring group of young women. They were desperately eager to tell me their stories. Their candor and ability to talk about this confusing period of their lives while being right in the midst of it impressed me. After our interview, one girl remarked, "You ask me all these things that I don't think about very much! People never come up and say, 'Do you feel like a beautiful person?' " Our sessions gave the girls an opportunity to question their identity and to reflect on their place in our society.

In selecting subjects for this book I sought diversity, not necessarily in ethnicity or class, but in personality and experience. All the girls interviewed for the book volunteered to be a part of the project. Yes, there is a certain kind of person who readily comes forward, but I did not want every one of my subjects to be bold and dynamic. I eventually chose a range of young women who are different from one another, each with her own distinctive qualities and sensibilities: troubled, sweet, unsure, hopeful, timid, daring. The girls included in the book range in age from fourteen to eighteen because I had hoped to focus on that time when a girl is no longer a child and not quite a woman. Originally, the project began at the private, suburban school where I teach. Then, I visited a rural high school seventy miles north of San Francisco. Finally, I interviewed urban girls from various San Francisco public schools, as well as teen moms from the East Bay. I did sixty interviews in all and chose thirty-six to be showcased in this book.

In retrospect, listening to so many young women talk about their development has forced me to reconsider my own. Their stories both informed and illuminated my own teenage experience, as I hoped they would. By getting close to each girl, I was privy to the unique person beneath the outward awkwardness and insecurity. Now, after three years of examining what it means to be female, I have more empathy for the girl I once was. I recognize that you can never entirely leave that girl behind; there is a part of her that remains with you always.

This book does not pretend to be a universal look at teenage girls. Instead, it focuses on what makes each young woman her own person. It was most important to me to recognize each girl's often buried individuality. The photographs and interviews were edited in a way that most accurately represents my subjects' true spirit. The young women in this book are not fash-

ion models or movie stars, yet they have a beauty and strength of their own. They want to be listened to; they want to be heard. What you are about to read is only a glimpse—it's what each girl said one day about how she sees herself. It's a moment in time, but it's a revealing moment.

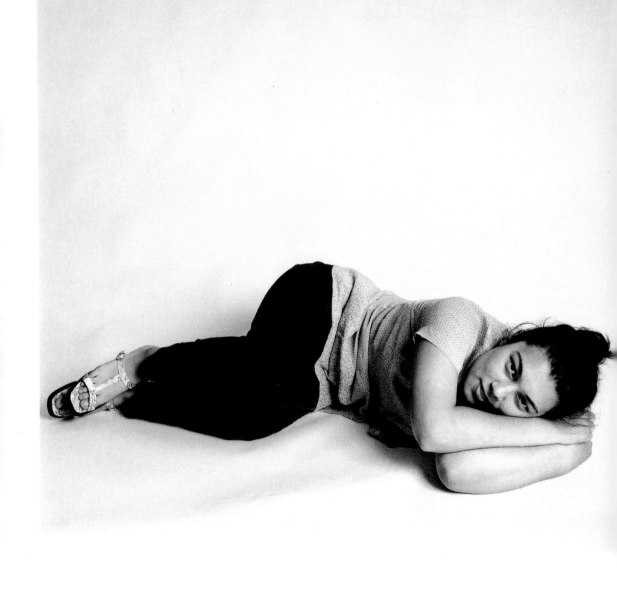

MAYA, *16*

I want to make a mark. I want my name to be in the history books. There aren't that many women's names in the history books, and that's something that just really gets me down. It's not that there weren't incredible women that were around; it's just that they weren't able to be leaders of their country and stuff like that. I want to do something where they can say, "That was Maya Wadleigh and look what she did." I want to do something with my life, something important. I'm thinking about getting into politics, or volunteer organizations, or even being a teacher. It's sort of a paradox—I want my name to be really big, but I want it to be because I helped others.

I do want both a family and a career. That's probably the biggest challenge. It isn't just, "Can I make it as far as my talent and ability?" but "How can I do everything?" My mom has her own business. She's so busy, she does everything. It does show me that it's hard, because she definitely gets stressed out sometimes. It's the balance that's hard to keep up, I guess.

I'm sort of lucky in terms of time and circumstances, because if you look back in history, women didn't have as much opportunity. Just the school that I go to, the country that I live in, and even being in the San Francisco Bay Area—it's a lot more liberal here. I feel I can do anything I want because I was brought up to believe that. It doesn't mean that I'm going to go out and be an engineer just because I can be; that doesn't appeal to me anyway. I might be in the typical mold, being a teacher or something, but that's my choice, not because society made me.

I think it's better to be a woman, but that's because I am one. I'm not out to prove that men are weaker or anything like that. Women are more able to express themselves; it's more accepted. It's not that they're more capable of having feelings, because everybody does; they're just allowed to express them. Males in our society tend to be cooped up. That's how they're supposed to be, really reserved. I wouldn't want that. I want to be able to express myself.

I think I'm beautiful, but sort of flawed, in a good way, because you wouldn't want to be perfect. I would describe myself as strong, dependable, and consistent. I know who I am right now, but I don't necessarily know what I am going to be. It's just something that changes. I could compare my strength to others, but I look at myself standing on my own. I look at it in terms of where I was yesterday, or a week ago. I look at the things I do as challenges—a challenge is what makes you strong.

AYELET, *15*

I'm a fifteen-year-old girl, your average confused teenager of America, because of the obstacles that astound me such as parents, school, grades, social things. I try to be different. I *am* different because I don't fit in with the norm, the mold of white T-shirt, blue-jeans America. I don't want to be looked over, I want to be noticed. I always imagine this line of girls, all of these girls standing in a line, and they all look exactly the same. Then somebody just passing over everybody, it's really depressing. When they got to me they'd say, "Wow, there's something to look at, a change of scene—better than looking at the same old thing."

I've been dealing with a lot of shit right now, like my parents especially,

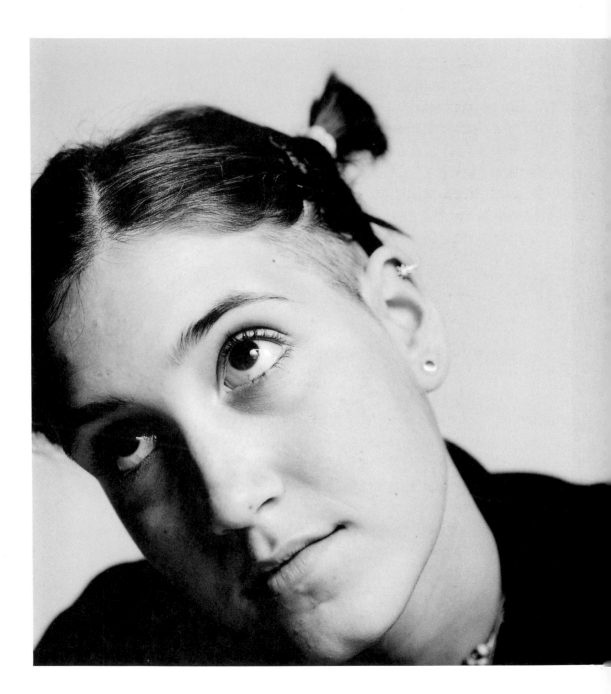

because they want me to be normal. I think that they don't want to be embarrassed by how I look or how I want to look. When they walk down the street they don't want to be noticed with a weird teenager.

They want to make me see a psychiatrist, which would be fine with me; I've always kinda wanted someone to tell things to, you can talk about anything. But the way my mom said it, she was basically saying I was crazy or something. I'm not crazy. I'm confused. I have things in my mind that I don't understand, but so does everybody. It's the nature of being a teenager.

I want to be free. I want to be able to do what I want to do—stuff that isn't threatening to anybody else, just things that happen, things that you do. I want a life that I can look back on and say, "That was fun." I don't want to be bored, I don't want to be too unruly. I just want a laid-back kind of thing where I can do 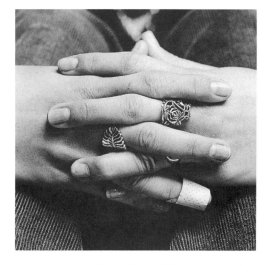 whatever. If I was able to communicate better with my parents, then I would be a lot happier.

I'm embarrassed because they don't let me be myself; they don't let me do things that other people get to do. They say, "Why would you want to do that? You can't do that until you're sixteen." But how am I going to have more experience to know *how* to deal with different situations if I don't do them until I'm older? Being older age-wise isn't going to help me anyway because I won't have done anything.

I just wrote a letter to my dad because I wanted to dye my

hair purple but he didn't want me to. I said, "If you learned anything in the sixties, it's that it's expected for you to be out of the norm, and it's not deadly wrong." That kind of got him, I think. So, supposedly, later this summer I'll be able to dye my hair purple. My dad basically thinks it's ugly. To me, it's just self-expression. Purple is my favorite color, so why can't my hair be purple? His thing was that somebody who needs to dye their hair to show who they are has something wrong with them and is just messed up and very lost. But that's not really how it is. I am more found and less lost than most people.

Peaches, *16*

Everybody that I ever really cared about gets taken from me. I don't understand. I don't even want to love nobody no more. I don't want to love nobody or care about nobody because they always get taken from me.

I'm not a little girl no more. If my daddy ever wanted me to come over, I'd be like, "Y'all took too long to try to be in my life. When I needed you, nobody was there for me." My mom used to come around, but she's been in and out of jail all my life. Some people take it as like, "Don't you be mad at your momma, just leaving you?" I don't, not really, because she did it for the best of me. She uses drugs, and she sells drugs. She be having all these men in her life. It be a lot of stuff going on with her.

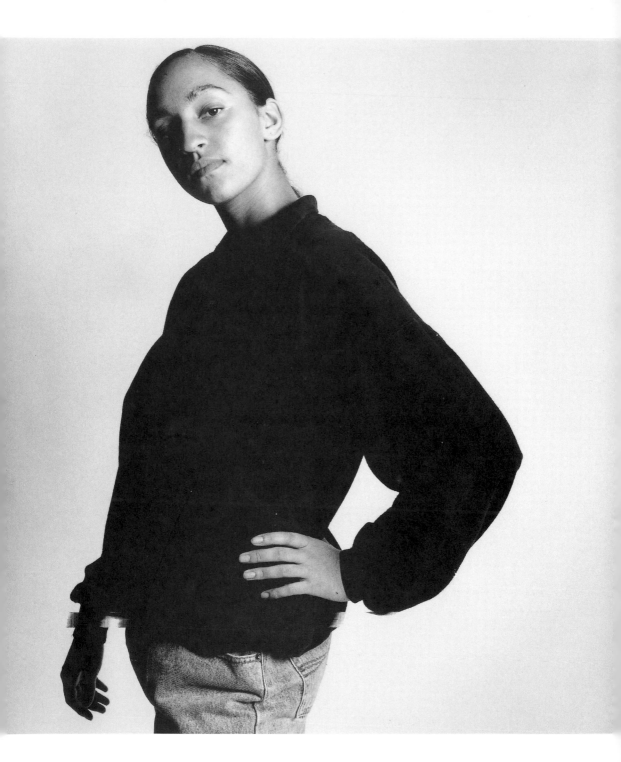

I'd be out there, too, if I was with her. I accept all of those things, but it's not something I like to be around. I did all that, smoking weed and selling dope. I'm only sixteen, but I already experienced that stuff.

A lot of my friends smoke weed. All the females that live by me, they drink every day, they all have kids. I be like, "Not! I don't have time for that." My mother and father wasn't there for me and I think that's cold, how I just got left. I wouldn't want to have to leave my kids.

It makes me mad to see people disrespecting their parents. All the stuff my mom did to me, I never disrespected her. I'll go downtown and see her, and she'll be looking so bad, I just wanna hit her, like maybe if I disrespect her she'll act right. But then, that's still my mom, so I cannot do it. Those girls, they don't understand. I'll be like, "Y'all lucky. Y'all got your parents here and you still messed yourselves up." I don't have none of that. I'd love to have some parents that was my own, not just borrowed or whatever.

I have to take care of myself. I don't have nobody there to do nothing for me; if I don't do it myself it ain't going to get done. I don't live with my family no more. I stayed with my grandmother all my life—she died in '94—then I lived with my aunties for a while. Now I'm on my own, basically.

I want somebody to help me. I know that I slip easily, I know that. For me, the hardest thing is to stay focused on what is going to help me in the long run. When I was in middle school I had a personal counselor that came to my school every week, I knew I had somebody to talk to. I used to chart my week out; I'd write out the date and everything I had to do for that day, so I wasn't going to slip up and get in trouble. In my free time, I'd just read and read and read and read and read.

When I got to high school they didn't have a counselor program, so I started holding stuff in and a lot more was happening

to me. When I was at home, I couldn't talk to nobody because everything I did was wrong to them. I used to smoke weed to clear my mind. When I stopped planning, my days started messing up, and I started getting in more and more trouble. I was just like, "Man! What am I doing?" I was smoking weed all the time, I stopped going to school, I was out there in the street. I could feel myself losing control.

Things was already hectic, then this year my best friend got killed. I was in shock. Me and him, we were real close. I got super depressed. I lost about fifteen pounds in a week. I was like, "Damn, I'm getting skinny!" I stopped talking to people. I would come in the house and just cry and cry. I didn't eat, I didn't want to see nobody. My mind was tripped out.

Then I was like, "I'm cool off this life. I don't want to do this no more." I started going back to school. My grades wasn't as high as they was, but I had Cs and that was good to me. Nothing never pleased my family, though. Unless it was all As it wasn't good enough for them. They always be like, "You need to be more like your sister." My older sister goes to UC Davis; she kept 4.0s in high school. Teachers think that I should be getting As because on my tests I get high scores all the time. When I get home, after I go to work, I don't feel like doing homework, so that brings my grade down. People be like, "You have to do this, you have to do that." I be like, "Fuck you! I don't have to do *nothin'*." I do what I want to do. My family, they say, "You gonna be just like your mom." I hate that, man.

Now I got a job so I don't have to be selling drugs. I don't want to be in jail; then I really would be just like my mom. I stopped smoking weed, I'm trying to prove that I'm not going to mess up. I want my family to accept me for me, however I end up. Even if I was on drugs, pray to God that I won't be, I want them to not always want me to be something I'm not.

They judge me, but they don't know what's really going on.

I be like, "Y'all don't understand what I have to be going through every day. Y'all think you know because you grew up here, too, but you don't know what it be like to be a young female out there." Plus, I'm light-skinned with long hair, girls be hating me for that. Girls threaten me and they don't be playing. They come to my school to jump me. I'll leave and my auntie be like, "Why didn't you tell the teacher?" Okay, what could the teacher do? These girls got razors and bats and stuff; they going to hit the teachers, too. Girls will pull guns on me; I seen them putting people in the hospital.

They just don't like me, for nothin'. They'll want to fight me over a boy. And a lot of boys be wanting to talk to me. If I walk away, I gotta be a bitch. They'll hit me, they don't care. I be scared not to say nothing to them, and if I do talk to them, I gotta be a ho. I be like, "Damn, what I'm supposed to do?" Sometimes I wish I could be deaf, so I don't have to hear them.

I always have the same dream that I'm going to die before I graduate from high school. I don't get shot or nothing; it's like a boy hit me, beat me to death. That's one of my fears, that I don't get in no relationship that's abusive. I be scared to mess with somebody who I know is violent. I just hope that I could finish high school. That's not really too much, but for me it is, because there's so much stuff that I go through. I be super special if I could just get to live to graduate from high school.

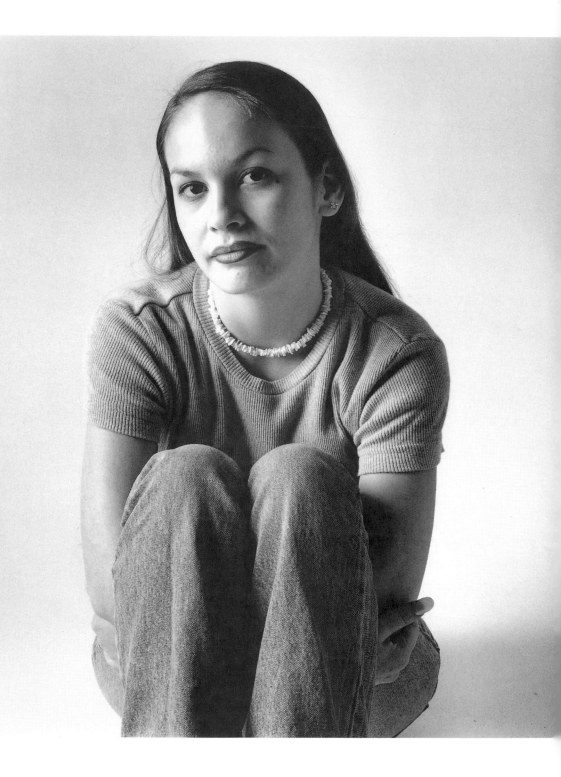

CHARLENE, *17*

I'm proud to be what I am. My mom's German and my dad's Filipino. I like to be mixed, I'm not ashamed or nothin'. But it is kinda hard, too, being biracial. A lot of people be buggin' me about my ethnicity. It be gettin' on my nerves, dude! I get hated on by hella people, especially Filipino girls; they don't like me 'cause I don't look Filipino, 'cause I'm white. That's one of the most annoying things in the whole world. They say, "Oh, yeah, you just trying to be Filipino. You ain't Filipino." Everybody wants to see my dad as proof. I don't need to prove nothin' to nobody, you know?

Sometimes I act kinda childish, but I've been through a lot and I have a

mature attitude about so many things. If you really get to know me, you'll understand. You can ask me anything, I've been through it.

I have been crying at school lately 'cause of this sexual harassment thing. My teacher talks to me the wrong way sometimes; he says inappropriate things to me. It makes me feel disgusted. The young ones going to our school are acting like that, too. But he's a teacher. I feel I can't say nothing to him. This happened last year with the same teacher, I did say something to him, and they made it seem like it was my fault. He's got more authority, so I can't do anything because they'll just turn it all on me again.

At my school, I'll be getting hella sexually harassed by a lot of the guys. They grab my chest and my butt, whatever. This one guy won't stop talking about my butt, and two weeks ago he grabbed me. And I see guys looking at me nasty. It's just disgusting. I experience it every day at school, and on my way home. I didn't expect it to happen to me, really, because I know everybody in the whole school, and I don't expect guys to be like that. It's so sad. They think it's all right to be putting us down.

I'm not the type to just sit there and be quiet. I'll say something. I let them know right then and there. When they look at me, I'm like, "Don't look at me like that." That guy that grabbed me, it was like a reflex; I just turned around and kicked him. That's happened *a lot* of times, I can't even count. Guys just love butts! There's a lot of guys that are perverts that I have to deal with every single day.

My whole life has been kinda hard. Now it's hella good, compared to before. In fifth grade, my mom and dad got separated, and my brother went to go live with my dad. Then my mom lost her apartment. Me and my mom had to live in this truck for a couple days. We moved back in with my dad, and then my dad lost his apartment, too. So we was living out in this garage, all four of us, for hella months. It was hard, I mean, we had to pee in a

bucket! Finally, my mom got an apartment. And then my mom and dad really separated.

I moved here with my dad. It's hard living with my dad. He's totally different. My mom's so flexible, and she likes my friends. If I had a boyfriend, she'd want to meet him. My dad is just like, "No boys!" Well, now he's getting used to it. I mean, I'm seventeen years old! He's way overprotective. Oh my gosh, he is so overprotective of me. He lets my little brother go out, and with me, he's like, "Be home at six o'clock," just because I'm a girl. I mean, I'm little, but I have a mouth; I don't let nobody push me around. My dad just sees this fragile little girl.

My friends make me happy. My dad tells me, "Oh, you shouldn't always think about your friends." But my friends are the ones who treat me right, and *know me* know me. I don't have to lock myself up in my room for them to know something's wrong; they can look at me and know. They're always there for me. I trust each and every one of them. We take care of each other.

I'm not gonna make no stupid decisions. I wanna be me, I wanna be who I am. And I wanna show my kids to be who they are, not to go follow anybody else. I'm gonna go to college. I don't want no crummy job, I want a good career. I wanna be happy with what I do. I want my kids to be proud of me. I want them to bring me to show-and-tell! I just wanna be able to support my family. I've been through enough struggling and I don't wanna struggle no more.

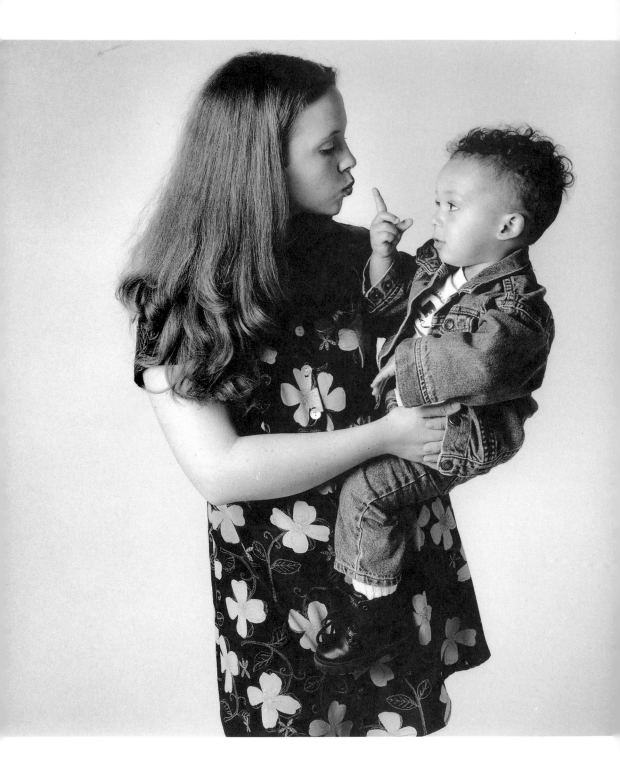

OLIVIA, *18*

I always feel I can do everything by myself. I don't need any help. You've got to be prepared to do it on your own, no matter what anybody says. I get that from my mother; she's all, "I don't need a man, I can do it." That's made me stronger as a woman.

My role in life right now is a mother; I'm a very good mother. People respect me because of that. A lot of people tell me, "You don't even seem like you're your age. You seem really grown-up." That means a lot to me. When I was in high school, I thought, "I'm a woman." Now that I look back and see how I was: that's a girl to me. In high school, you're playing games, and you're always after the boys. I was really

selfish; it was all about me. I gotta think about other people now; I got other responsibilities.

I was sixteen when I got pregnant. I was doing bad in school, I was cutting class all the time, I was behind in credits. I was living the life, you know? I had that mentality. I knew I could get pregnant. Me and the baby's father had been together since freshman year. We just never worried about it. I was on the pill for a couple months, but I was like, "Oh, I hate this thing!" I'd forget to do it; it wasn't worth it to me. I wanted a baby. I never considered adoption, abortion, nothing. I thought that if I got pregnant, it was meant to be.

We moved in together when we found out I was pregnant. He was working, I was working, everything was going fine. But he wasn't ready for that. He won't admit it, but that's what it was. He wanted to party all the time, he wasn't coming home at night. He got fired from his job. I'd come home and the house was dirty, nothing's been done, and he's sleeping in the bed. That's when I moved out.

I got a baby now, it's a full-time job. I can't worry about other people all the time. I told him, "You did the first couple months, we got eighteen more years to go." He wants us to be together, but I need him to straighten up his act before he can come back. I said, "I don't need you. I can do this by myself."

People think that when you have a baby your whole life is down the drain. They say all your dreams are shattered, but they're not. They're put on hold. You can still accomplish things. I have to plan for my future now, because of the baby. I have to plan for his future. I don't see myself going to college anytime soon. Financially, I can't afford it. I'd have to have a really great part-time job. Right now, I'm just hoping to get my foot in the door of a good company where I can keep moving up, and hopefully make the money that I need to support myself and my son. I'd like him to go to college, but I don't really see it happening for me.

What's really hard about being a teenager is keeping on the

right track, because there's so many distractions. They can just bump you off the rail, and trying to get back on is harder than getting off. It's hard to stay focused on your schooling, which is what you should be focused on. You don't understand how important it is to have a diploma until you're out there.

People look at teenage mothers like, "Oh, they're all on welfare, and they're going to become nothing." I'm not gonna be a statistic. I'm not on welfare, I'm working, my son is more than provided for, he has everything he could ask for. I'm a good example. I'm not living off the system, I'm supporting myself. I get help from my parents every once in a while, but it's nothing to be accounted for. I'm not some dumb little teenager.

Most of the people I've talked to, they say, "You're taking on a lot of responsibility." I don't think about it. You just do what you have to do. I don't think, "God, what am I going to feed the baby? Where am I gonna get the money?" You just do it. And I can't think afterwards, "Hey, I did a pretty good job." I did it because I had to.

When I think about my son in the future, I start to get scared. I start to think, "Oh God, please don't let him get into gangs. Please don't let him do this, please don't let him do that." But he's going to live his own life, he's gonna do what he wants to do. I just hope that he will lead a normal life. I don't want him to get shot, I don't want him to get hit by a car, I don't want him to get beat up 'cause he got a Walkman. It's scary, you know? I hope that I never, ever have to outlive my child. I just want him to grow up, be a good kid, have fun. I really hope he has that chance.

I want my son to be proud of me. Sometimes when you're little, you're embarrassed of your parents. I don't ever want him to be embarrassed because I'm an alcoholic or anything like that. I hope that I can instill in his mind, "I'm trying my hardest for you." I want him to be proud that I'm his mother, and I want him to be proud of what I'm doing.

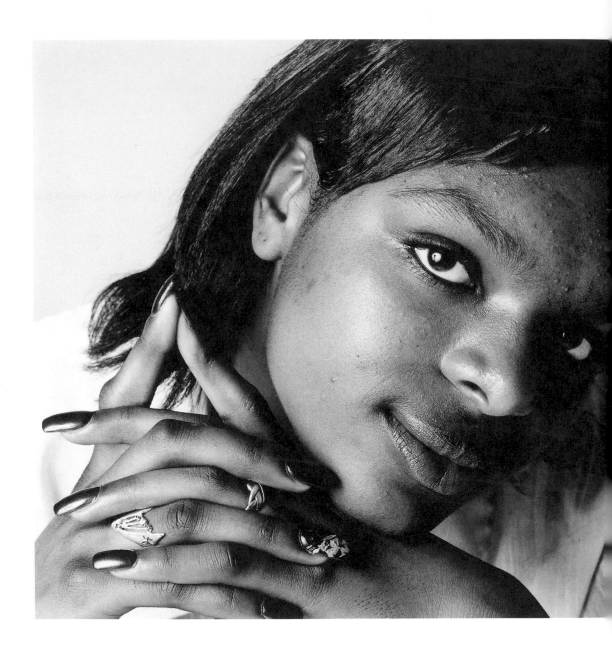

GINJUR, *15*

I try to look out for other people. I put myself on the line for somebody else if I think they need the help. That's how my father was. He was always helping someone, no matter what. He inspired me. So, I'm gonna help people. I'm not gonna be sittin' around doing nothing when I could be doing something.

My father died last year; he had a heart attack. I seen him. He was just laid out on the ground, smiling. Have you ever smelled death? I have, and there's nothing like it. I was just like, "Daddy, wake up! I know you're gonna get up, you gotta get up! Daddy, stop playing!" Everybody was looking at me. I was shaking him, hard. I'm like,

"Daddy, you gotta wake up!" I was begging him, "Please come back!" I felt like he left me. There was an emptiness in my heart, I was just so hurt.

I stopped going to school for a while when my father died. I'd go to school for one day and then I wouldn't go for two weeks. My report card was all Fs and Ds. At first, I played like I was going to school. I'd say they sent us home early, or I'd go to school and tell them I'm sick so they'd let me go home, I'd write fake notes. No one checked. After that I didn't go to school for two months straight. My school did not call my house, not one time. Everybody thought I was okay, because I was lying to them. I'd be like, "Yeah, I'm going to school, I'm getting good grades," smiling in they face.

I was very depressed. I'd eat too much, then I'd stop eating. I wouldn't be hungry. I'd lose all appetite for anything. I was mad at my mother, I'd say things that was so nasty they'd make me wanna cry. I had to look at myself. I was like, "Why am I doing this? I'm not doing nothing but hurting myself. My daddy wouldn't want me to be here like this."

I thought I understood until I went through it. I could always help people with their problems, I'd have a solution that would seem magnificent, they'd be like, "How could you do that? How could you help me like that?" I even helped my momma sometimes. But I couldn't help myself until it was too late. I fell behind five, six months in school.

Man, I've just got to finish school. If you don't have an education, you don't have anything. Not only do you have to have a GED or a high school diploma, but you have to have some type of trade. I know it's gonna be hard, but I don't care how long it takes me. I'm gonna graduate, across the stage.

It's hard coming up in these times. If you don't have your mind set, you won't get nowhere. You've got to have your mind set, you've got to have a plan on what you doing the next day. I know back in the day they probably said it was hard times, too, but

it's a lot of things that's changed. What I see outside, it's a lot of drug addicts, it's a lot of drug dealers, violence is everywhere. It's hard times for everybody.

I think my momma is beautiful, because she was there. She didn't leave out on us, she didn't go get coked out or cheesed out, she didn't go out there and start sniffing anything; she saved herself. She stood her ground. She was like a rock when everybody was falling apart.

I sometimes pick up the Bible and read it. It's not what I go by every day, but what I do get out of the Bible, it sticks with me. I know whatever they got written down in the Bible, it's got to be true. To me, it's a guide to life. I don't know why people go to psychics and ask them things, when the psychics probably read the Bible.

I believe in God. If there wasn't no God, we all wouldn't exist. There has to be a God. But what I don't understand is where God came from. That's what I want answered. In the beginning, it even says there was nothing but lava and volcanoes shooting off, there wasn't no dirt, there wasn't even water. Where did God get the idea to have water and grass and everything? Where did he get the idea to get the shape of the human? And if they made it up, whoever made God up, they smart! They very, very intelligent, because they got a lot of people fooled.

I'm not afraid of nothing. I am not afraid to die. Most people die when they fear it. I believe you can make anything happen yourself. The only fear I have is to be a drug addict because it's not easy escaping it, unless you run from it, and it's not good to run from anything. If you start running you ain't gonna never stop. You just gotta face it. You gotta be strong inside yourself.

If you feel comfortable with yourself, you're gonna do what you wanna do no matter what anybody says. Don't nobody have a remote control on your mind. I don't take no trouble from nobody, no messin'. I stand my ground wherever it needs to be stood. They

say money makes the world go 'round, but it's really you, your self, your soul, your heart that makes the world go 'round.

My hero is my father. He was just "the Man." The outcome of his life was joy. But he was tired. When you're tired, you go to sleep, and that's what he's doing—resting. I'm gonna see him someday. I'll be happy, smiling because I've seen him, even if it's in my dreams.

ALICE, *17*

I have a vision of what I want when I'm older, and it usually includes a woman. I want to have a nice little house in San Francisco and live with somebody that I love, and have a job that doesn't drive me crazy. I see myself coming through the door with groceries and she gives me a kiss on the cheek; we sit on the couch and watch old movies, and it's a really sedate lifestyle. We don't go party every night, we don't have five million friends that we always have to keep up with. It's just comfortable, but not boring.

I'm really worried about the future. I worry about where I'm personally going, and where America is going. I worry that California is going to pass a bunch of dumb

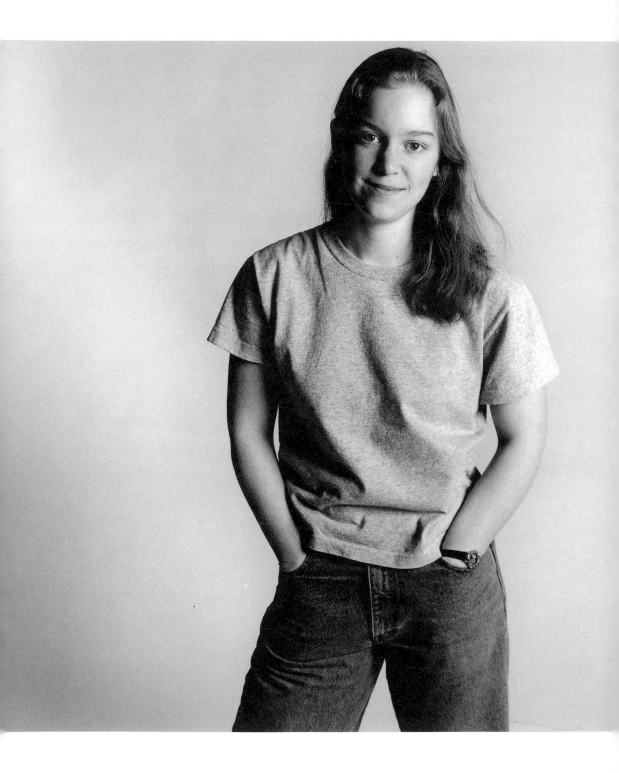

laws, or that we're going to elect some lame president and I'm going to want to move to Denmark. I worry that another country is going to get into a war and we're going to get dragged into it. I'm worried that you guys polluted the planet and we're going to have to clean it up.

Most of the teenagers I know think about their lives a whole lot; they're really analyzing it and going, "Where am I going?" "Where am I now?" "How do I get where I want to go from here?" Teenagers are a lot more cerebral than people give them credit for. They're interesting people when you talk to them. Teenagers have more of a shaky grasp of the world, but it's more real. It's not set in stone yet. Adults have had the same job for twenty years, have a couple kids, live in a house, do the same thing every day. They've got their values set, they know where they are, they know where they're headed, it's the same road. Teenagers are on this trail that has four hundred little offshoots; you can go anywhere and you can always come back and start all over again.

We're a lot more sophisticated than teenagers thirty or so years ago. We have way more opportunities, we have to be more mature. Either that, or the antithesis would be teenagers becoming ultra-immature, to completely ignore it all, which is dangerous and scary. Part of being a teenager in any era is that you're irresponsible, but today it's a lot more serious. We can get on the Internet and into a chat room where somebody wants to have cybersex with us. AIDS is out there, making the whole sexuality thing a big deal. Not only should you not have sex because you could get a girl in trouble, now you could get her dead. We have to think more about the choices we have.

People always freak out about high school kids having sex. I freak out if they're having sex without a condom. But the act of sex, we're designed to do that. There's nothing wrong with it. I'm sure if I fell in love with somebody I'd say, "Right on! Let's go!"

I'm gay, with occasional straight tendencies, but women

make more sense to me. I don't hate guys; mostly I'm disinterested. Every once in a while I meet a really cool one and go, "Wow! Aren't you neat? I'm intrigued." By and large, I think women are more interesting. With girls I'm always like, "You are so sexy. And women are awesome, and you're awesome in your own woman way."

My family is really supportive. They really supported me when I came out. They said, "Fine. We love you anyway. It doesn't matter." I was afraid they were going to hate me, and they were great about it. I shouldn't have underestimated them like that, but did, just to protect myself. They let me do my own thing, we all do our own thing, then we gather at the dinner table and talk about those things. It's probably the best part of my life because it's the most continuous part of my life.

When I was little, I was always doing things that the guys wanted to do. It took me until eighth grade to realize that I don't even like baseball. One random person who I don't even remember anymore said to me, "You can't do that, you're a girl." I was like, "Oh yeah? I'll show you!" So I bought myself a glove and got my best friend, who happened to be male, to teach me how to play baseball. It was because it was a boy's sport that I wanted to break into it. I do that all the time. If you say, "You can't do that because you're a girl," I go, "What the hell is that supposed to mean?" I immediately want to do it. I have this little crusade going on where I'm like, "I am woman, hear me roar."

MARIA, *17*

Ican be pretty dangerous being a teenager. We just don't think about what's gonna happen later. Some girls get in gangs and do drugs because they make them feel good. But they just get in fights with other girls on the streets, and you never know if they have a knife or whatever. You don't really care at this age, you risk your life a lot.

I don't wanna risk my life getting in gangs. People get in gangs because they don't have enough support from their parents and their friends. If you go out for a gang, you have fun, do what your parents don't let you do, go home at five in the morning. You're drinking and doing drugs because they have it for you; then you're stuck there.

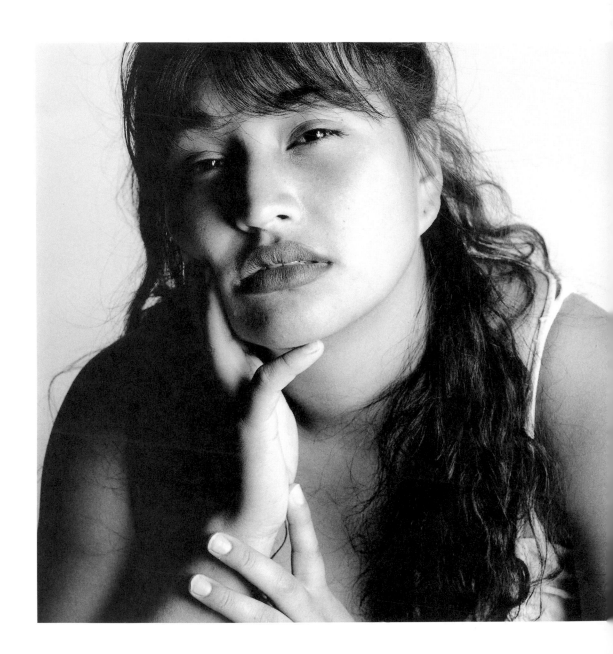

My brother used to be in a gang. He was never home. If he ever was home, he was there to ask for money. He would always be in trouble. Always. Now he's in jail. We don't really know what happened. He said he was never home because my dad would always tell him, "Go to work! Go to school!" That bugged him and he just felt like being with his friends where they didn't tell him anything.

I'm Catholic. It's important because it's part of the family tradition. We go to church every Sunday, and that's good because that gets our family together. I mean, my family's always together, but that gets us more together because we all go to church, and go out to dinner after that, and talk about things. We're a very close family. My biggest fear is losing one of my family members. That's the thing I always have nightmares about.

My sister tried to do suicide. First, she grabbed a knife and tried to stab herself. Then I grabbed the knife and took it away from her. She went to the bathroom crying. When I opened the door, she was hanging. She was purple and green. She's pretty heavy, and I don't know how, I just lifted her up like so easy, and took the cord from her neck. She was okay after that. I was like, "Think about what you have! You have us and you have two babies!" That really got to me. Now I'm afraid; I don't know if she is going to do it again.

She was depressed because of my dad, supposedly. She's my dad's little girl, and he told her, "You gotta stop going out—you got two kids!" She thought she had to get pregnant to get out of the house. Now, she's divorced and she has some other husband and she wants to get divorced again. I worry about her a lot.

I've learned from her. I don't want to have kids right now. They say it doesn't stop you, but it does, because you can't go out after school, go to parties, go home when you want. After I'm twenty-three, I'll probably change my mind. Right now, I don't want

to get married. I still want to have fun. I don't know how I'm going to get through that. But I'll be fine if I don't find a boyfriend!

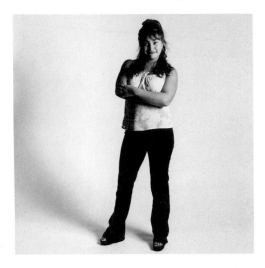

This is my last year in high school. I have to start thinking about my future now— that I have to leave my house and all these things. I want to go to college. My parents expect me to have a good career, but they don't tell me what I have to do. I just want to get lots of money so my mom and my dad don't have to work— so I can support them.

XOIE, *14*

The most positive aspect of my life would prob-
ably be me. I love who I am, I love being me. I wouldn't want to change.

I've grown up on hippie communes basically my whole life. People say, "It's so
beautiful out here." Yeah, it is beautiful, I will admit that, but the sound of cars driving
by puts me to sleep. I just love being in the city. Being out in the wilderness is so
much scarier for me. I don't want to live on a hippie commune! I wish I lived in the city,
that's what I've been dreaming of ever since I was small. I like being around people.

When I'm up on Star Mountain, I can't stand silence, so I end up blasting disco
music, going off, dressing up at my house. I have all these crazy seventies polyester

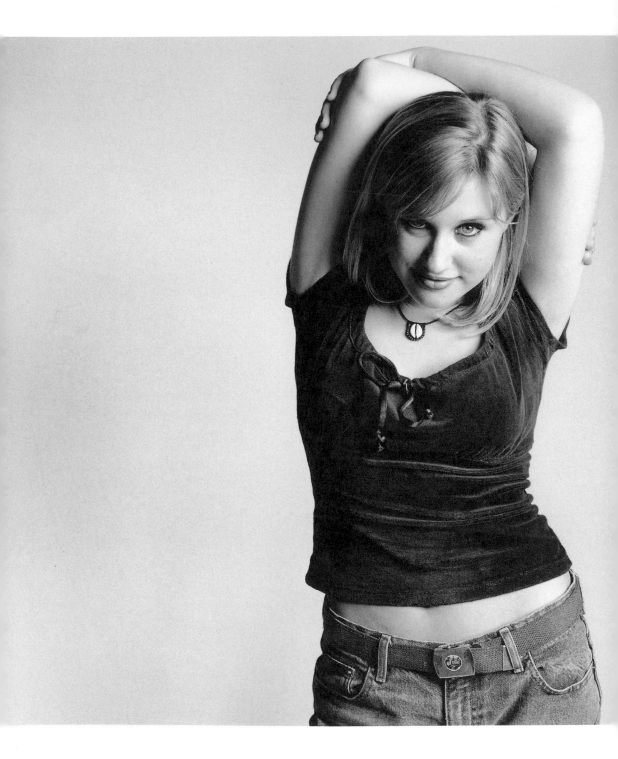

clothes. It's so much fun, I love dressing up. I love to sing, I'm gonna try to get into singing or acting. Marilyn Monroe is my role model. I'm infatuated with her.

I love clothes. I'm a total clothes addict. My room is just two feet of clothes. You walk in and you can't get anywhere. I've always been obsessive about what I look like. I don't go around checking myself out in every mirror I see, but it's always on my mind, like, "Gee, I hope I look all right." I love makeup, I wear makeup every day. I like dressing up, I love making myself look good. It's so fun. Then you get to go around and look good and it's cool.

My mom and I went through the whole teenage thing when I was eleven or twelve. She had like an anxiety attack because I developed really early. I had boobs in fifth grade; nobody else did. We went through this phase where everything I said, she contradicted, and everything she said, I contradicted. We'd get in these fights because we're very alike and we can't stand each other sometimes. We were ready to kill each other. I seriously wanted to kill my mom, like no doubt in my head, I wanted her dead. I was wishing she would just keel over.

But we started bonding. Now it's cool because she trusts me and she's not worried about me doing like drugs and stuff. I smoke pot once in a while and it's cool with her. I'm allowed to do it in our house. She told me, "I'd much rather have you doing it where I can keep an eye on you, than you trying to sneak off somewhere and getting caught and arrested." I'm glad that she's laid-back like that. I'm allowed to have guys over to spend the night. She knows I'm not going to screw around with them or whatever. She really trusts me.

It's so much more fun to just hang out with guys than to have to go out with them. They're so lame when you're going out with them. First of all, they try to show off. That's the worst because they end up making such asses of themselves. Guys

expect me to put out, because I have boobs and because I'm pretty, I flirt, and I wear tight clothes. I always have older guys hitting on me. I straight tell 'em, "It's mine, not yours. I decide. I don't give a fuck what you think. If anything, I'm doin' *you* a favor." Guys expect girls to let them do whatever they want. If you don't sleep with them you're a tease, if you do sleep with them, you're a slut. What are you gonna do?

I'm still a virgin and I intend to stay a virgin until I am at least fifteen. I'm not gonna be a tramp. It doesn't matter what other people are thinking, or if somebody's pressuring you; it's your decision. It's not cool to throw yourself away like that. You should respect yourself.

WREN, *15*

I think the world has expectations of me because

I am a young black teenager. There's an expectation that I am going to fail, or just that

I am doing something wrong. Sometimes I get frustrated, sometimes I get mad, some-

times I get upset. I don't let them know that I am, but I'll go home and cry about it.

I'm very strong willed, I guess, pigheaded. I know what I want, to an extent: I

want to be rich. I'm spoiled. I'm given everything I want, but I have an understanding

that my father had to work for it. He doesn't just shovel out the money 'cause he has

a tree in the back. He goes to work, I see him work every day.

I don't want to get sidetracked off of college, graduate school. I have the same

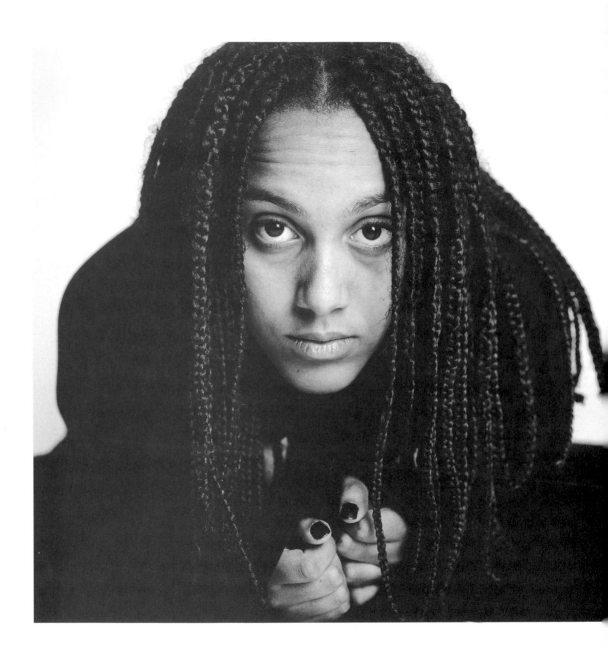

hormones as every other teenager, and right now is when teenagers start falling off the path. I see people totally going off on the wrong track, and that happens when they're sixteen, seventeen. It's really hard for me to have those same hormones, to want to do the same things that they want to do, but to resist. Drugs. Going out partying. Boys, you know what I mean? I'm not trying to save myself for marriage or anything, but I see a lot of girls ready to have sex and I don't know if they really are ready. I know I'm not.

One of the things I'm worried about is, once I'm rich, how my kids are going to handle that. I'm worried about my kids being too secure. I definitely see that at school. Everyone there is so sheltered and coming from the same background. I feel like they're dumb. They feel like their lives suck, and they don't. I mean, I don't have to go home with them, but nobody's life is that tough, at least there. If you're sheltered, that's fine, keep your innocence. But don't be rude and insulting about the things you don't know about.

Once I sat down at a table in the cafeteria. This girl started talking about her friend doing cocaine, she was almost bragging that she had a friend doing cocaine. She was being obnoxious, but that's okay. Then, all of a sudden, I heard, "All black guys do cocaine," or something like that. I looked up, and I said, "Excuse me, what did you say?" I was really offended by it, you know? They were like, "Oops! I'm busted, there's a black person at this table." There's only like five black people in my school, out of three hundred kids. They're not used to having to watch what they say.

I was just like, "Why am I at this school? Why am I even dealing with this stuff?" I've heard people tell me, "You should be the one to educate these people that not all black people are like that and that's just a stereotype. You should be the one to enlighten them." I do feel that it is my place to do some of that,

but it's not *required* of me. I'm not a preacher. I shouldn't be the example that has to be perfect.

I can't really do much about it. At least one bad thing, what I consider in my own little world really traumatic, happens every day at school. And the next day, I'm like, "Oh God, I have to see that person again." That's when I feel weak. Going home is like my favorite part of the day. Just going home and being with my family and my sisters, you know? It's just a completely different world.

Anna, *15*

When I was in eighth grade, my parents did not understand me one bit, but that's okay because I didn't understand me either. They thought, "She's our daughter; we better make sure she does what we say because we don't want her to turn out to be some weird, depressed loser." Then that got kind of old and it was like, "You know what, this isn't working. Why don't we just let her be what she wants to be?" It made it a lot better; then they weren't trying to be so pushy. Now they understand me more. They just say, "She's Anna, whatever goes. She's kind of strange, she's a little unexplainable." My parents understand why I'm going to school in a disco outfit, because I

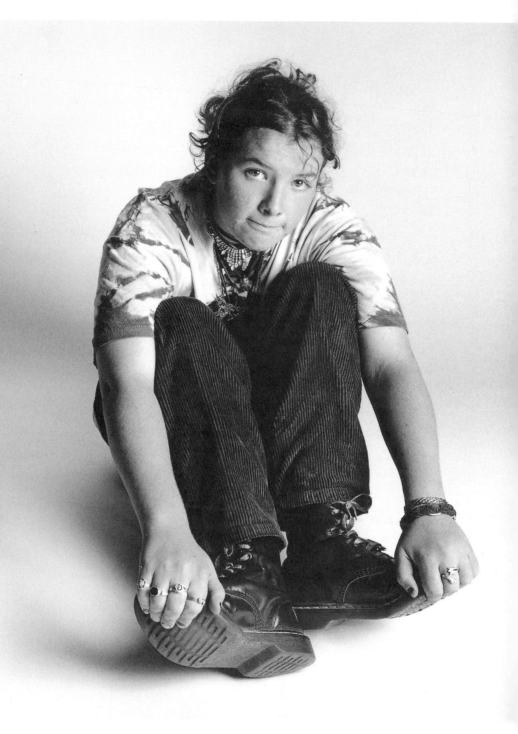

feel like it. A lot of the things I do in life are just because I feel like it.

Most people think that I'm a freak because I'm different from them. I don't go very well with normality and trends. I know a lot of people that are like, "Oh, well, all the cool people get drunk on the weekends, so I'll go do that, too." Where do they end up? Not very far from home. But I'm going to be a movie director when I grow up. I'm going to make a lot of money and when I'm making my great Oscar speech, I'll say: "First I'd like to thank my mother, and all those people in school who thought I was really weird and stupid."

The people that I admire are successful. People that take something simple and make it into a great success and are happy. I expect for myself to become somebody and go somewhere with my life, and that's how my parents think, too. At school, people expect me to be weird and do whatever other people don't do. Some people are sore thumbs, but I'm a painted thumb; I stick out on purpose. I like the idea of being a big, painted thumb that's got orange and blue on it, because those colors don't go together very well. It's very defiant and very solid. I like being me, I can be a whole bunch of things at the same time.

There is no "normal." But if I had to classify normal, it's what everyone tries to be. If someone is going to cover themselves up and be a different person so someone will like them, that's kind of pointless because then they like the artificial you and they never like *you*. For a while, I thought, "Maybe I should be cool?" Then I decided that was a stupid idea. I figure I'll do exactly what I want to do and how I want to do it. I'm very independent. I don't think it's hard. If you are you and you don't try to be anyone else then it's pretty easy because there's only one of you.

I wear birds in my hair a lot, little Styrofoam birds. People go, "You're weird." And I go, "Why am I weird? Actually, from my

point of view, you're weird; you want to be like everyone else." It's an opinion, it's not a fact. Why am I weird? Because I'm different? Actually, it just makes me more special.

I think I'm very beautiful, I don't care what other people say. I look realistic. Some people have so much makeup and polyester clothing on, they look like a piece of plastic, so fake and artificial. They'd look much better as a person instead of a Barbie doll. I don't really like Barbie dolls. I used to have one, but I put her in the microwave.

ALETHA, *14*

I'm an outspoken person. I speak my mind. Some girls, they act like little girls because they're not intelligent or mature enough to speak their minds. If anybody asks me, I tell them what's real. I don't hold nothing back. I like for people to hear me, to hear what I have to say.

I'm the youngest in my family, so people are always telling me, "You're just a little kid." I don't think I'm a little kid. It's what's in your mind. It's not your age or how you look. I see myself as a young lady. I am very intelligent. I've been through a lot of stuff in my life, with my mom and my dad and all of that.

When I start thinking about my dad it makes me sad, 'cause he's been gone

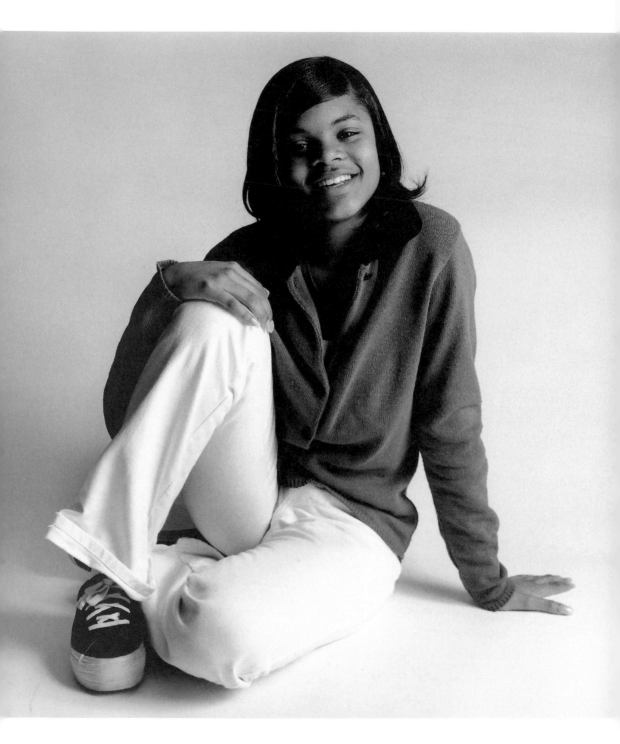

for so long. When he left, I was only five, so I didn't really get to know him. He called us one time after he left—one time, and that was it. We hadn't seen him in years, and then, all of a sudden, his sister got in contact with us and we went to go see him. It was hard for me to call him "Dad" because it didn't feel like he was my dad. I haven't talked to him since.

If I could, I would ask him why he left. I mean, I know it's not my fault, but I would ask him, "Is it because of me and my sisters? Is it because of my mother?" I just wanna know why.

That's something that stuck with me for a long time. I used to cry about it night and day. My mom used to have to sit up with me all night until I stopped crying and fell back asleep. I still think about it but I don't let it get to me as much. My mom just tells me, "It's gonna be okay. Don't worry about it." She tells me that I'll pull through. And those are the words I go by.

My mother has been there all my life. She's a strong person. She's taught me so many things. Some teenage girls feel that their parents shouldn't know anything about them, but I think my mom should know everything about me, because she's my mother.

All my life, my mom's been like a friend to me and my sisters. She has talks with us about sex, boyfriends, getting pregnant. She tells us how to take care of our bodies. She tells us all kinds of stuff. She tells us a lot about herself that she won't tell anybody else.

I like my lifestyle. I like where I'm at right now. We don't have a lot, but we have enough to get us through. As long as my sisters and my mom are there with me, I'm fine. We help each other. I can tell them anything. I just want my family to be there. Those are the only people that I care about.

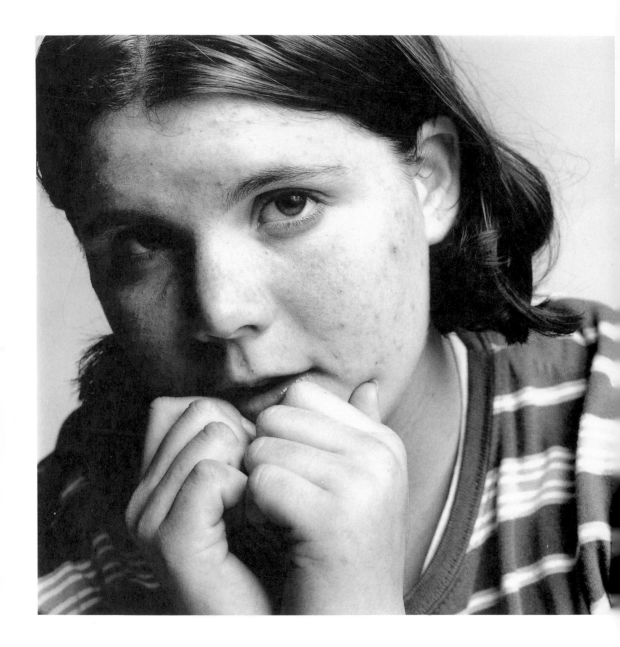

ASHLEY, *14*

Who am I? I don't really know. I'm still figuring that out. I think it's part of being at this age. I'm changing now—I can't say that I'm totally a child, and I can't say that I'm totally a woman, because I'm not that experienced. I'm right in between. It will be better when I'm a couple years older, because right now I'm supposed to act like an adult but I can't drive, I can't do all the things that I'll be able to do when I am an adult. But this is the "best time of my life," supposedly, so I better enjoy it.

It bothers me when adults think that every kid is a bad kid just because they're a teenager. I hate hearing, "When I was your age I had to walk ten miles in the snow,

uphill both ways," because now I have to walk through some gang neighborhood and look out for drive-bys. It's terrifying. Teenage pregnancy and gangs and stuff, I wish I didn't have to deal with it. I'd rather be alive in the fifties, basically. Everything is an issue these days.

People think I'm a freak or something. They automatically think that because I listen to rock music or dress the way I do that I'm not a good kid. I wish people would understand me, I wish people were a little more open-minded. People who really know me know that I'm actually a nice person. I want to listen to everyone and give everyone their chance, because I know what it's like if nobody listens to you.

I worry about everything, I'm really nervous. I worry about life itself, and what people think, and "Who am I?" I get anxiety attacks. I wonder where I'm going, I wonder things like, "How old am I gonna be before I die?" But I'm slowly learning that there's not much I can do about anything so I should just live now.

My parents have been divorced about six years. The divorce was real tough. It was a whole custody battle and the divorce itself took a year and a half. It wasn't pretty. It doesn't seem right for anyone to hurt anyone else like that. Sometimes parents tend to use the kids in their own problems. I was stuck in the middle. I'm sure they don't see it that way, but when you're that young, how else can you feel?

My parents, they're human. I'm angry at my dad, but he's sorry, and there's not anything else I can do. It wouldn't do any good to hold a big grudge against him, because then that would just make everyone miserable. I look up to my mom a lot, because she's basically all I've got. She listens to me and she takes care of me. She puts everyone else before her, which isn't always good because then she gets hurt, and I know how that is.

I've been hurt in my life a lot of times, but the thing that gave me the biggest impact was definitely the divorce. It made me

think in a lot of different ways. I grew up all of a sudden, real fast. Ever since I was eight, I've been a little adult. I've been taking care of my own stuff and being responsible so I don't give anyone else anything to worry about. It can be hard. Sometimes, I want people to be more concerned. But they're so used to me being capable of doing everything myself, sometimes they don't bother. I wish I could have been a little kid for longer. But I just had to grow up. I didn't have any choice.

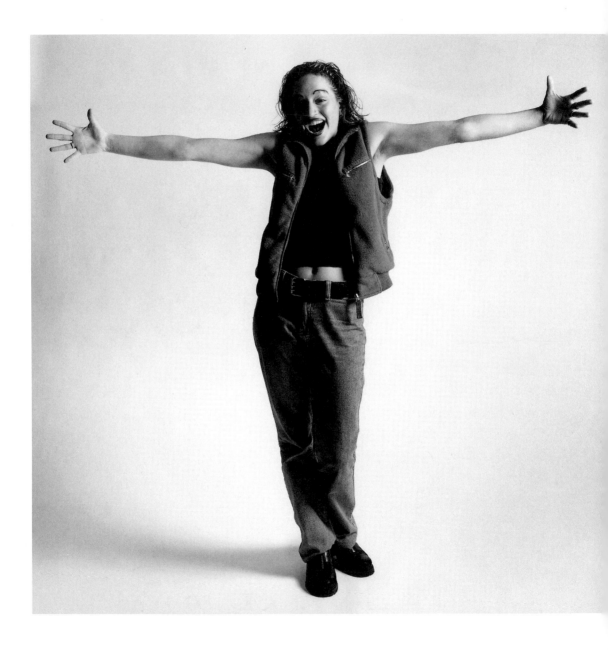

THELMA, *16*

It's hecka cool to be a girl. I'm wild, outspoken, crazy. I do what I want to do. I'm a musician. I play guitar, I'm in a rock band called "She." It's five girls. I help write the songs, too. I love music. That's what I want to do when I'm older. I want to have a career in music, I want to inspire people. If you're a musician, people love you. That's what I was meant to be. If I don't make it, I'm going to be mad. I'll be miserable at anything else. It's just going to happen eventually.

My mom expects me to be good and finish school. I don't really go to school that much anymore. I used to get good grades, but now I hate it. I'm lazy, I don't like getting up in the morning. And it's kind of dumb. I don't get challenged by it. They give

us easy work. I see it's not easy for some people, but I'll be finishing hecka quick, and I'm like, "I'm done." When I went to middle school they had honors classes. That was better because that was harder work, but at my high school they don't have honors classes. I was getting good grades; then I got tired of it. It was boring.

My last report card was full of Fs because I didn't go to school. I just got enough credits to be in the eleventh grade, and I'm going to do better this semester. I'm going to get all my credits, then I'm going to do summer school and night school so I can pass. It's important for me to graduate on stage, for my mom.

My mom, I used to be her baby. Now I'm older and everything's changed. I try to please her; I do everything she wants me to do, but she's still mean. My mom chooses my stepdad over me. That hella hurts. That's why I see myself alone in this world. I wanted to kill myself. I set a fire in my room, to try to get my mom's attention. She was like, "You're crazy."

I wish I had a relationship with her, where I can tell her how I feel, or stuff I go through. I don't really talk to her. And if I do, it's not like she cares. I don't tell anybody my problems, I can't. I don't have anyone there. Nobody. I just stay in my room and cry. I hate it. I hate sitting there and thinking about that stuff, because I just go crazy.

I smoke marijuana and it makes everything kind of better. I smoke pot almost every day. I don't pay for it. It's there, free, every day—if I'm going to school, when I'm out of school, when I'm hanging out. It's everywhere, in my face. I never thought I would be one of them people that smoked weed. I was like, "I don't understand why they do it." I think that's what messed me up in school. I'd go to sleep and not want to wake up. I never thought I'd get stuck in it, but damn, I did.

Society thinks most teenagers are bad, I guess because of the whole drug thing. A lot of teenagers are doing it, and that is going to bring us down, but we still do it. Probably they picture us as all bad-asses that just want to do drugs and have sex. I think a lot of girls have sex to please other people, not realizing the bad that could come out of it, like AIDS. That's scary, and it's so easy to be passed. A lot of people be doing it on drugs, and they be such in a rush they be not even remembering about it. I saw this poster saying, "You're going to get AIDS for four seconds of fun." It's so true because a guy, all he has is like a four-second orgasm and he could get AIDS off of that little nothing. Damn! I think they

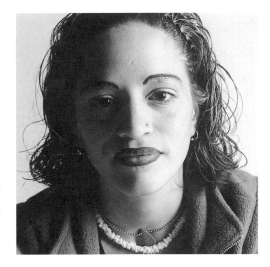

should put that every-where, all over TV, so kids would actually realize that you could ruin your whole life, just for four seconds that you enjoyed your-self. People would really start using pro-tection if they knew that kind of stuff.

I'm not really a virgin, but I am. I never did it the whole way because it hurts too much. It kind of sucks because it hurts us when we first get it done, and *we* have to get periods and *we* have to have babies, and men don't have any of that pain. When I die I'm gonna ask God, "Why did you do this to us? Why don't they have to suffer?"

I don't ever blame God for things. That's how life is. If it's bad, eventually it makes me stronger. I'm a musician, I need to have something that I'm hurting about. No matter what happens, I always have my music.

The only thing that keeps me alive is my dream of being famous one day. That's the only reason I haven't killed myself yet. A lot of people don't back me up. I'll say, "I'm going to be famous." And they'll be like, "Yeah, whatever. Ha ha." They laugh at me. But watch, one day I'll make it and I'll show you all.

RENAE, *17*

As a teenage girl, the biggest issue is respect. Going through high school, finding your own identity is *huge*—finding a niche where you can say that *this* is who you are, finding your own thing that you can claim so that other people will recognize you. It drives a lot of girls just crazy, it drives girls to do crazy things. They just need something to identify with, they get into the wrong crowd, they end up doing things they don't want to do and then, that's that. It's hard sometimes to remember that you have your own brain and you can use it.

I don't want to grow up. It brings to mind sexuality, just emanating a whole different being. I don't want to be that yet. I don't really want to *be* that, flat out. I just

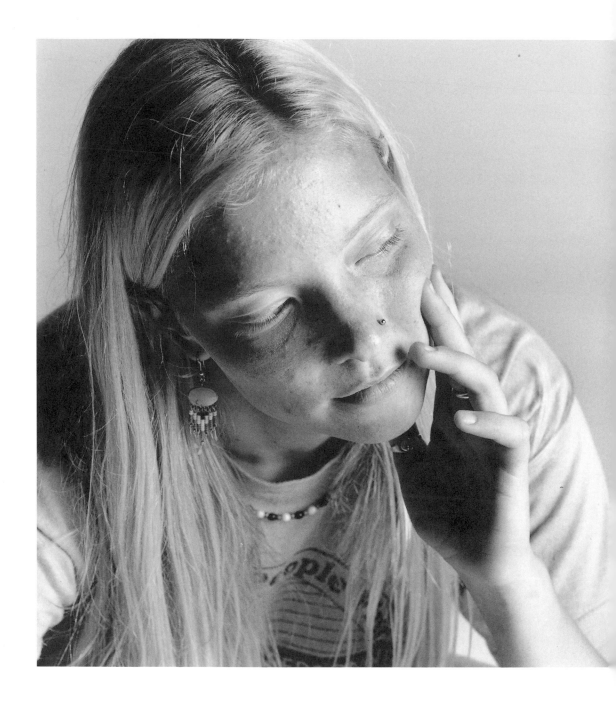

want to ignore it. I don't want to be viewed as sexual. The way that I dress reflects the image I want to put out. It's comfort, basically. I want people to pick up that I'm comfortable. Women or girls that dress a certain way are using their sexuality or their appearance to get things. That can lead to people making generalizations of women as a whole, and it's really disgraceful for people that don't want to be perceived like that. It's kind of a violation. I know people that wear low-cut or tight shirts, and I don't think they're insecure, necessarily. Mostly, they want to be noticed and they want to be wanted by the opposite sex, and, you know, they just want to be wanted.

It seems like guys expect the girl to be pure and innocent and perfect, but at the same time to satisfy their needs and wants, their sexual pleasures. It's a total contradiction. I have friends that haven't really wanted to have sex, but felt like maybe they could keep the guy if they did. I always thought it was such a cliché, just something they talked about on sitcoms, but I've heard it come out of my own friends' mouths. They say, "Maybe if we have sex then he'll care about me more." The guys say to the girls—ooh, I've heard this a few times—they say that it's important to them, too. They say, "I know you're not that kind of girl. And I respect you, and I love you." They say that a lot. I don't know about every single guy; I'm sure there's some sincere ones out there. But I've heard it when it wasn't sincere. Guys are so weird.

There's nothing that I'm afraid that I'm going to fall into. I have a sense of who I am, what I want, and what I don't want, to lead myself where I want to go. I'm not afraid that I'm going to end up in a position that I don't want to be in. I respect myself. I have a tendency to want to get through things by myself. I don't want to depend on other people for my well-being.

I'm going to be independent. I probably will end up having kids and a husband, although it's not important to me right now. It's not something that I see myself needing to have for survival

in the future. Women, nowadays, are supposed to go out there and conquer the world. It's a lot to expect, being a mother and a successful businesswoman or whatever. But it's encouraging, to be expected to get out there and conquer.

Basically, what I want out of my life is being around people that I trust, and having people trust me. Obviously, I want to be successful. Success to me means happiness, and happiness means having people appreciate you for who you are, not for your money or anything else. I don't necessarily have to be famous and make a huge impact all across the world, but I would like to be some inspiration for people to look on and be like, "Look, she's strong, she's doin' her thing. It's not impossible." My biggest hope is that I keep strong morals and a sense of what's important to me, that I can look back on my life and say, "I'm a good person," and that I'm as happy with myself in seventy years as I am right now.

JENN, 15

I want to have less judgment, I want everyone to have less judgment and just not talk about people so much. I include myself in that; I'm definitely too judgmental. Girls, when they get together, that's just what they do: talk about looks and what she's wearing today and how she acts. Guys couldn't care less about other people, but girls do. It's very competitive in the girl world.

There are a lot of expectations. If someone says, "Oh, you have the perfect body," or whatever, I don't want to let that go. That just means I have to stay that way. Looks are very important. I don't think there's even one overweight person at my school. That's a lot of pressure. You don't want to be the one overweight person.

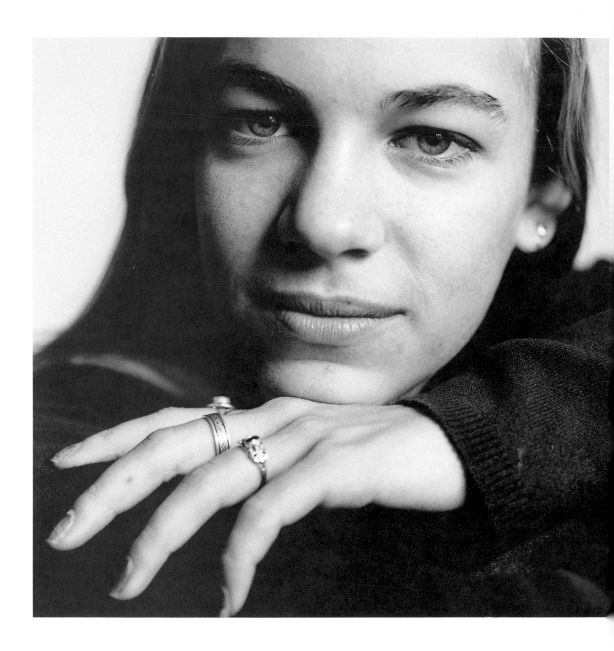

I have this problem with staying at the perfect body. If I gain weight I want to get it off as soon as possible. I had to be in the hospital for a while, but I didn't think I needed to at all. My mom took me because she was worried about me or something. Then they were like, "You should be in the hospital," because, like, whatever, I met the criteria for anorexia. But I definitely don't think I needed to be. I mean, I pretty much like my body, so my problem is I want to stay that way. I guess I went about that the wrong way and I have to learn how to deal with it.

I wish I was a little thinner because they made me gain weight in the hospital and I want to get back to what I was before. I was a lot happier. I have to go to clinic twice a week. You pretty much have to stay at that weight or keep gaining weight, or else they're going to make you go back in the hospital. There's no way I want to do that. You just don't know; it was so scary going in there.

I wanted to get out of there as soon as possible so I'm like, "Okay, whatever I have to do, I'll do it." It made me worse, it made me think more about it. I never really worried that much about food, but now I constantly have to think about what I'm eating. I feel trapped because I'm totally controlled, it seems, by the doctors. If I didn't have clinic I could be happy. I can't even exercise because they don't want me to. Exercising was a huge part of my life. I did it every day and now I can't and it's really annoying. I tried. I ran for a little while after I got out of the hospital, but then I almost had to go back in because my heart was all weird again. So, I stopped that. I cannot do anything I want to do as far as my body goes. It's all these controlling things.

I didn't want people to know, but it got out anyways. I mean, I knew it was going to happen. It's funny, a lot of people backed off. People used to say, "Oh my God, you're so skinny!" Now, they never say that. My close friends still say, "You have a good body"

and that makes me feel good. I'm glad they keep saying that, because after I gained weight I kind of doubted it.

My friends right now, I don't know why, but a lot of them care so much about what they look like. It seems to me more, maybe I'm just noticing it now that I've been in the hospital. I don't know if I brought it more to their attention. Some are becoming bulimic. I don't know how to handle that, you know? What do I do? In the hospital, you learn that telling them things like, "You look good," is not good for some people because they want to keep going. If they look good then, they can look good ten pounds lighter. Also, a lot of people do it for attention and you don't want to keep giving them attention. But there's so many different reasons that you don't want to do anything. Sometimes I have to just let it go.

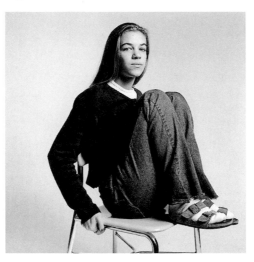

I see myself as happy, compared to a lot of other people. I am really ambitious, I know exactly what I want to do and I work towards that. I'm always busy; after school I have five things to do every day. When that builds up, it's hard, but that's pretty much who I am.

My parents, I don't know if they expect it, but they definitely want me to get good grades, no matter what. I guess because of this school and this environment, they expect me to be something. I've always wanted to be an actress and they're like, "Okay, but you need to have a background position, something just in case

you don't make it." Here, you just expect your child to grow up and be a lawyer or a doctor. They know being an actress is a hard life, and I'm sure they're just looking out for me. It doesn't strike them as something they put me in this school for.

Friends, by far, are the most important thing to me, above other things that I know it should be equal with, like family and schoolwork and stuff. But I like to be alone, too. There are a lot of expectations, and you can kind of let those go for a while. When I'm alone, I feel like I can be sad. I don't talk about my feelings to other people, I keep them to myself. I don't know myself that well and speaking about it, you kind of have to know how you feel. I definitely care about what people think about me; that's a huge part of me, so that could be it. I like to be alone, then I don't have to know, I just am.

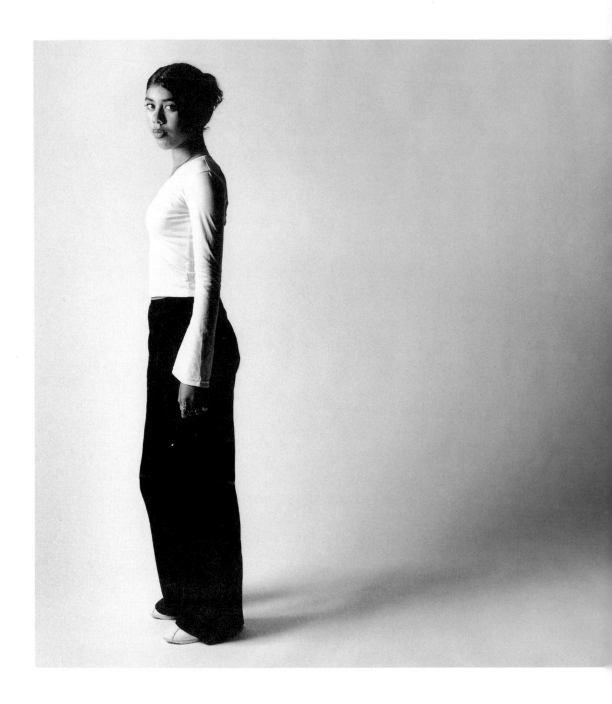

LAURA, 15

When my parents got divorced, I was only six and I still remember everything. I was crying, I didn't want my younger brother to see that I didn't know what to do. I felt very weak at that time. But then again, I felt strong because I was like my brother's second mom. I was helping him with a lot of things, I was helping him with school. My dad would have to go to work and I would have the food ready and everything. That has something to do with the way I am, because I do almost everything in the house. I do almost all the chores; sometimes I do my dad and my brother's bed, too. I think my dad is very grateful because of that. A lot of people would be all down and crying all the time, and I'm not like

that. Not me. Before, I used to cry about it, but now I'm stronger.

I like the way my dad raised me. I don't agree with him sometimes, but I know everything he does is for my own good. He doesn't let me do a lot of things, like if I want to go to a party, he sees the kind of people that are there; if they do drugs he won't let me go. I know that's good, because he doesn't want me to drink or smoke pot. People say, "You did a good job raising your daughter." I agree. I'm happy with who I am. It was hard for my dad, because I'm the only girl, I'm the oldest, and he's been raising me ever since I was six years old, by himself. I have a lot of respect for my dad.

My mom, I used to have a lot of hatred towards her because she cheated on my dad, but I've gotten used to it. I look up to my mom, too, even though she hasn't been there for me for a long time, I just see her once a week. I look up to her because of the way she is. She's a really strong woman. People, they don't push me around, but they'll say something and I'll let it go. I wish I wasn't so nice. I look up to my dad because he's nice, I get that from him. But my mom, sometimes she's mean, she won't let people push her around. I wish I was like that.

With my dad, I fight with him about the confidence he has in me. I tell him, "Dad, you should trust me more. If you don't trust me, I'll never be able to do anything and you're not going to see the kind of person I really am." I used to do things behind my dad's back, wear certain clothes or whatever. Now, he wants me to tell him things. He said, "I might get mad, but if I do it's because you're probably doing something wrong that you're not supposed to be doing."

We had this very long talk. At first we were yelling at each other, but then we talked about it and he was like, "Okay, this is your opportunity. You can say what you want to do and I'll let you." And I was like, "Yeah, right." I didn't believe him, but he did. That's when I told him that I had a boyfriend. He didn't want me

to have a boyfriend before and I told him that I already did, I'm not gonna break up with him. So, he was like, "Okay, but I want him to respect you and I want you to respect him, too."

I'll obey my dad and my mom, but basically everything I do is just to please myself. People my age, they say, "Oh, I have to be this way," just because their friends are like that. The way that I am, if people like it—good. But if they don't, then too bad. I'm not going to change because somebody wants me to, I'm not going to change the way I think. I don't try to be like anybody else. I have a strong mind. It's just the way I am.

People expect you to be a certain way when you're a teenager—you have to be mature, serious, like a grown-up. Sometimes I act like a kid, the way I sit, the way I talk. I get excited about the smallest little things. People are like, "I have to be serious." They're so serious, they hardly ever talk. When I get old, like when I'm thirty or fifty or something, I hope that I have the same spirit that I have now.

JENNIE, *16*

I'm a person that likes to have fun and be with my friends. I don't like school. I like to be myself and not what anyone else wants me to be. Not what my parents want me to be, not what my teachers want me to be. I'm not going to get good grades because my parents want me to. I know it's important to get good grades so you can go to a good college, so you can get a good job, so you have a lot of money, so you can live in a nice house, so you can die.

But I wanna live basically like if I died tomorrow, I could say I've lived a good life. I think about people that just sit at home and study, on weekends. There's so many things that people miss out on. It's sad because, yeah, they're gonna be rich,

maybe, and have a nice house, but what are they gonna have to look back on?

Drinking is fun because you loosen up, you can have fun. It's just something to do. Some people go home and watch movies, but that gets so old. I don't drink that often, just at parties on the weekend, I'll drink about six beers. If I drink one night, I probably won't drink the next. I would never drink on a weeknight. If you have limits and you know what you're doing and you can hold your own, then it's totally fine. I don't think there's anything wrong with it, as long as you stay out of a car and don't go totally crazy and like rob a store or something. Just have fun and live your life.

In the world, I hate to say it, but a lot of good jobs come from having connections or sleeping your way to the top. It's sad but it's true. If Claudia Schiffer walked into an advertising agency and wanted a job she didn't know anything about, and the boss was a guy, he might think, "I'll give her the job; at least I'll have something pretty to look at." Guys are just like that. They can't help it, it's in their minds. It's in the movies and the magazines and everything. That's why they buy *Playboy*s. It's just disgusting. It's not like I whip out *Playgirl*s and start looking at them. I think that's gross.

There are stereotypes that society puts on women, that they should be skinny and beautiful. Bulimia and anorexia and diet pills are big; there's a lot of diet pills at my school. If guys are interested in you, then you think, "Well, there's nothing wrong." But if they aren't, then you think, "Am I too fat?" There's so many skinny girls you compare yourself to.

Boys—unfortunately, they expect too much: sex. They're not going to get it, not from me, nope, nope, nope. Seventeen, sexual peak, all guys expect sex. It's kind of sad. I haven't entered that stage of the world yet because no one's been in love with me. I want someone to love me rather than just be horny. I want to feel cared about. Girls are more emotional, and guys just want to tell

the guys, "Guess what?" It's like, "Yeah, it doesn't matter, it's just another girl." Some guys are really nice, but some are just like, "Boom, boom, boom, drink beer, fuck girls."

I feel like guys pressure me to have sex but I don't care. Obviously, if they're not going to be there because I say no, then they're not going to be there if I say yes. I have friends who could be dying of AIDS right now; I'm not going to risk anything. If I did have sex, I'd have protected sex, but there's no way in hell I'm going to put my life at risk for someone else's pleasure.

CARMINA, *17*

I'm a very quiet person, but when I feel lonely I like to get attention from other people; so I start talking even though it doesn't make any sense. I just try to make conversation so I won't feel bad. Sometimes I really need somebody to talk to. I don't want to depend on somebody. It's just that I feel like nobody cares. I think I'm weird, because I should have somebody to talk to, at least. I don't really trust my friends. I don't trust anybody, not even my mom.

My mom is overprotective of me. I'm glad that she cares about me, but at the same time, I think she should let me go and experience my life while I'm young. It

makes me feel that she doesn't trust me. She's like, "I don't even know what you're doing. I don't know who you're hanging out with. You're probably doing drugs, you're probably having sex." She thinks that I'm the worst person. And I'm like, "What are you talking about, Mom? I'm not doing any of that stuff." I don't like to hide stuff from my mom because I know that she's gonna find out sooner or later.

I don't think I'm an interesting person. When people ask me what I do, I don't have anything to tell them. My life is simple, it's really simple. I wish I had an interesting life, but I don't. I just stay home, I do my homework, I don't do anything interesting. I don't even listen to the radio. Sometimes I feel that I'm weird because I don't do any kind of stuff my friends do.

It is hard to stay away from trouble, but teenagers should live their lives the way they want, not the way other people are living it. You should do things positively and independently and believe that you could do whatever you want to do. Depend on yourself, not anybody else.

I stay out of drugs because I had some bad experiences with friends that offered me drugs. Now I realize that a good friend wouldn't let you even think about it. One of my friends asked me to do acid with them. They were telling me, "It's not going to kill you!" But you have to think about it, too. What if something happens? What if they take advantage of me? What if my mom finds out? One of my sisters? They're gonna get disappointed; they won't trust me anymore. I don't want that. Guys live a much easier life. Their moms, they don't ask them, "Where are you going? Who are you going with? What time are you coming back?" They don't have to tell anybody what they're going to do.

I don't trust guys. They're like, "Oh, you're really pretty, look at your eyes, your lips." They're always going to tell that to every girl, not just to you. When I look in the mirror, I see a person that's ugly, that nobody likes.

I'm just a simple girl. I read a poem that Ralph Waldo Emerson wrote about transcendentalism, and I liked it because it tells about how simple life is. We make it so complicated, we overreact about things. I think that's true. People should live their lives the way they want. They should follow their own beat of the drum.

EMER, *16*

I've been working out my own philosophy, my own version of a religion. I don't go with many organized religions, because they have a whole thing that you're *supposed* to believe. You need to choose what you are going to believe, because that's what's going to be truest for you. If you were to have a religion for me, I'd be a pagan, in that I believe that there has to be a goddess and a god; there can't be one or the other. There has to be a balance. For that particular reason, paganism relates very well to feminism. Well, feminism in the way I see it: not necessarily having equal rights, but having equal respect.

I've pretty much grown up with a feminist, my mom, even if she doesn't think

of herself that way. So it was always taken for granted, for me. My mom is not what you would call an active feminist, but I'd see a movie and she would always have some comment about how the woman never had any part in it. For a long time it was just, "Mom, give it a break." Then I realized that she was right. It wasn't just one movie to pick on; it was really out there in the world.

I know my parents trust me. This is something I've thought about a lot. I've never wanted to do drugs or alcohol or anything like that. I came to the conclusion that I refuse to be used by people. I was trying to figure out why people wanted to, why they would end up doing that. I hate not being aware of things that are around me. My parents have always trusted me, and if I ever wanted to smoke pot, they know that I wouldn't get carried away with it. That's why I think I never had a need to. I don't need to prove anything.

Being a teenager is confusing. As you're growing up, your body and mind are working along together, getting this nice arrangement going. Then you hit puberty and it all goes to hell. Your body goes on ahead without your mind, and then it's all trying to catch up. Hopefully it will by the time you're twenty, or else you're really screwed up. This is the time when you're supposed to figure out what you want to do. You're finishing high school, you're entering "the world," and you don't know what's going on in your own body. That makes it really hard. People deal with it differently. Some people deal with it by simply going all out into whatever they feel a teenager is *supposed* to be doing. I don't think that's necessarily what they would have chosen, but that's just easiest. Since I decided at an early age to rebel against popularity, that didn't leave me with many options.

When I was younger, I didn't like the way I looked. I thought I was too fat, I didn't like my body at all. I hated it, to be perfectly honest. It was more than just I thought I was overweight—I wanted to be taller, I wanted to be thinner, I didn't want to have

the kind of build I had. I'm still not entirely happy with my body, but I'm getting there, by changing my perception. In our society, we have lost touch with our bodies. You're almost separate from it instead of living in it. One thing that's helped me a lot: I take belly dancing classes. Anyone can do it, any size, and it works better with people who are overweight, supposedly. I went through periods when I'd look in the mirror, and I'd

think, "God, that looks awful!" But something clicked for me, how I felt about my body, and it's really a lot of fun.

I don't have a thing about being thinner anymore, although I would like to be more in shape. But that's a big difference, because I'd simply like to have more muscle and do more than I can. I don't necessarily think I'm beautiful, but I like the way I look.

Who I am is definitely changing. Sometimes in a good way, sometimes not. I'm still trying to figure it out. I see myself somewhere in between a woman and a girl. I haven't grown up yet, and I don't think I ever will. It's not a matter of age, because I'm sixteen and that's supposed to be this great landmark. On my birthday, it was like, "Wow! I turned sixteen!" But I don't see myself as a woman. I don't know when I will, but I think I'll know when it happens.

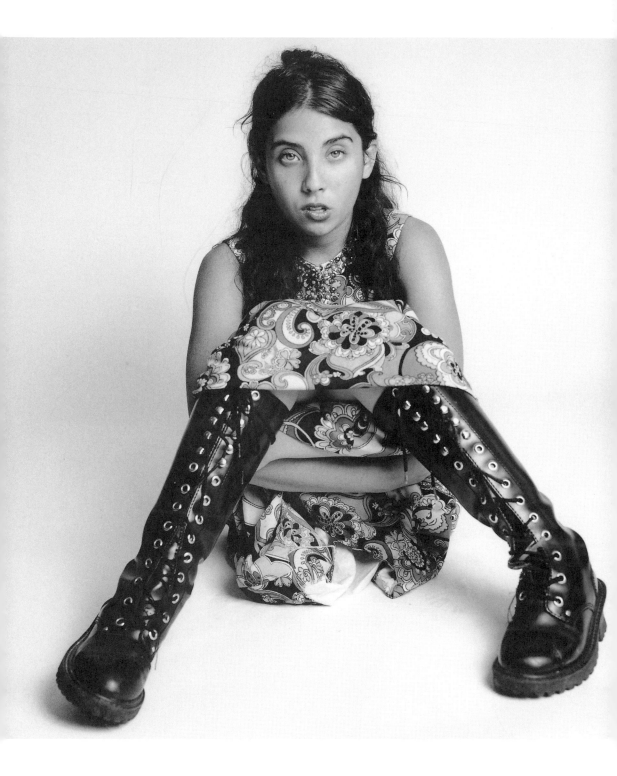

ALYSSA, *17*

I am glad I'm a girl. Societally it's better, it's more free in terms of like expressing yourself. Girls are smarter, in a way. I don't mean it to be like a feminist-dummy comment, but they have more intuition and more psychological insight. Guys are fun, but they don't understand things the way girls do.

Males mature a little slower than females. I don't have a lot of guy friends. I've picked out a few that are mature. I have a boyfriend, I guess we feel like we're equal. There are mature and intelligent guys out there. But at this age, at school anyways, it's hard to find guys that you can talk to the same way as girlfriends.

It's easier for girls to be bisexual without being treated with hostility. For

males, if you experiment with other males it's more like dirty. I don't think anyone wants to say that they're gay. People don't mind saying, "I'm bisexual," because that's cool, at least for girls. I've had experiences with girls, but it's more of like an experimentation phase. I see girls in a beautiful way and sometimes I can have a crush on a girl. It's not the same hormonal feeling as with a guy, but I do get infatuated with girls. I think all girls do to some extent, but I guess I've acted on it more.

Everyone kind of has bisexuality within them. There are bisexuals who are driven equally in both ways. I'm in touch more with my bisexuality, but I don't think I'm a bisexual.

It's kind of silly to be a feminist. It's just separating females from males by making categories. There's a line between supporting women and going to the extent where women are better and it's just reversing the whole problem. It's hypocritical to want to make things better by making it worse. "Feminazis"

are women who think men are the root of all evil, and women have power and should be able to do everything, and our society is aimed to bring the woman down. It's kind of overboard. There are a lot of advantages for girls, because a lot of options are open now, even more so than for males. You have female roles that you've always had, plus you have things that were male roles.

I don't think men and women are equal. They're different. When you have different bodies and different hormones, you're going to have different situations. I'm not going to be able to be a

football player and a man can't do a lot of things a woman can do. They can't have children. It's not equal. Equal is a weird word to use if you're comparing two different things.

I think there is a lack of confidence and more self-consciousness in girls, and maybe that is what restrains them. But it's something you need to overcome and not blame on males, or blame on an institution. You have to take responsibility for yourself.

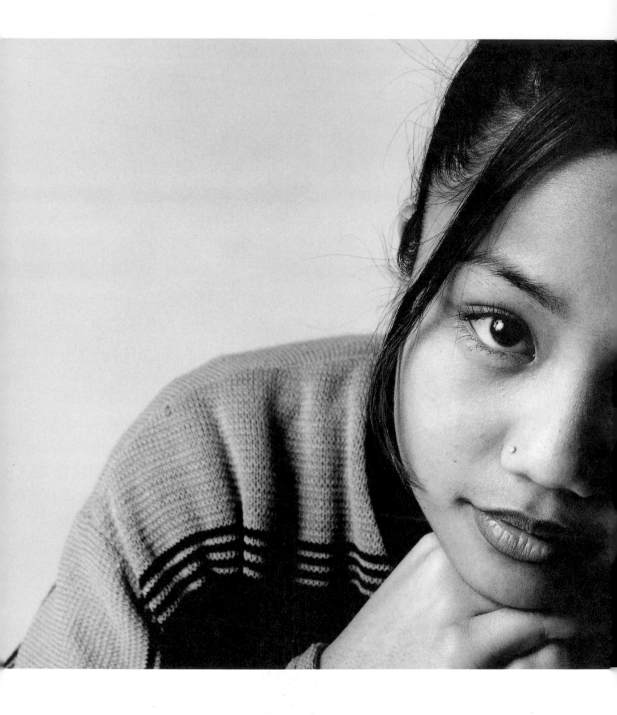

ARLENE, *15*

I wouldn't say I'm a pessimist, but I don't like looking at the bright side of things until they really happen. I don't like getting my hopes up and then all of a sudden everything goes the opposite. I had that happen to me too many times and I'm sick of it.

Last year, I didn't care about nothing. I wanted to stop everything, I just did not care. My mom was telling me, "I don't know how to raise you no more." I just be like, "That's your problem." All I did was go out and have fun. I'd go home and my mom would be there trying to lecture me and I just be like, "Whatever! I don't want to talk." I'd slam the door in her face.

I never went home. I never asked permission to do any-thing. If my momma asked me where I'm going, I'd be like, "I'm going out." I'd leave the house by noon, and I'd be back the next day. I'd only go home to sleep and to take a shower. I didn't even go to school. Out of the whole year, I only went to school for like four months. I messed up. I used to go to an academic school, and now I go to the drop-out school. I messed up big time.

I think I was rebelling. The death of my dad had a big effect on me. My real dad, I didn't know him; he died when I was a baby. But then my momma remarried, and he was my dad. He treated me like I was his real daughter. And I lost him, just when we were starting to get close. I was nine. Life just put that in my face: I don't have a dad.

We got into a car accident, the whole family. We were on the bridge, and he was having a stroke. My mom told him to pull over so he could take his medicine, but instead of pressing the brakes, he pressed the gas. He hit the side of the bridge. My mom lost an eye. My little sister, she was two at the time, got thrown out of the windshield. They found her on the hood of the car. She had brain damage; she was in a coma for two months and she had brain surgery. She's better now. It's weird, 'cause she's like smart. She's in third grade, but she has the IQ of a fifth grader. I guess you could say it's a miracle.

After my dad died, I put my whole family aside—I blocked them out. I didn't know who to blame. I was stuck. I was religious, but I stopped going to church. I was just like, "If there really is a God, then why is all this stuff happening?" I lost all hope, I just gave up. I was pretty depressed. I wanted everything to end, I wanted to be with my dad. I thought about killing myself, but I never went through with it. I'm happy to say I don't think about that no more.

My mom was at the point where she just didn't know what to do. She told me that she would cry herself to sleep, and I felt

bad 'cause I made her feel that way. I mean, it wasn't all me, but I was part of the reason. One time when we were arguing, she told me that she regretted having kids. That made me think. I was like, "Oh, man. What did I do?" When I was little, I was like momma's little angel. And I was doing the exact opposite of what she expects from me. My mom would always tell me, "The way you treat your parents now is the way your children are going to treat you." I look at myself and how I was, and if I have a child like me, I don't know how I'll deal with it!

I look up to my mom. Although I gave her all those problems, she's always been there. She's strong. She's a single parent and we had our bad times but we came out pretty good. My older sister's going to college, and I'm doing better in school, I'm getting As. I'm proud of my mom. She's the best thing that ever happened to me. Now I'm trying to help my mom as much as possible. I started to change gradually, and I'm still in that process of trying to be good. And so far, I guess, I'm doing fine.

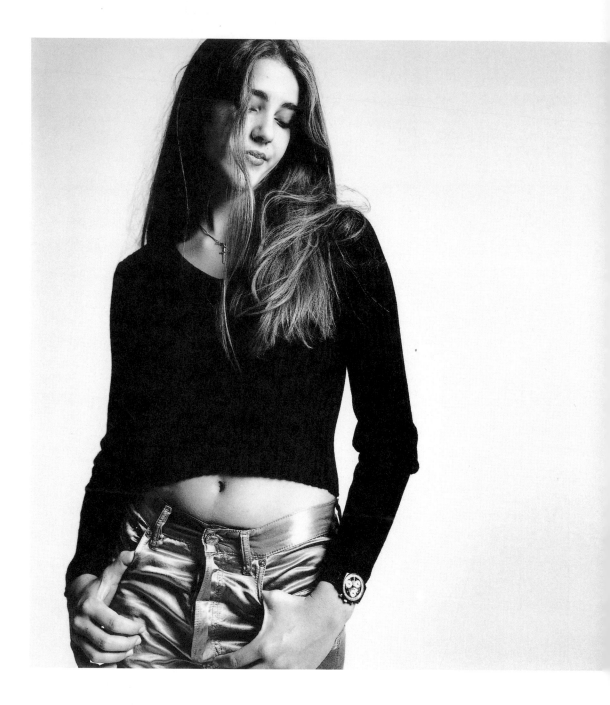

GRACE, *15*

There's so many things I want to do and be in my life, and I know there's not going to be enough time to do all that. I was thinking about being in the Peace Corps. I want to be in the army. I want to travel extensively, I want to see everything, I want to meet everyone. I want to be an explorer and do search-and-rescue. I want to do something that I know is going to help someone. I'm interested in mental health services, like going with people who have drug problems. It just really interests me what goes on in people's minds. I'd like to be a studier of characters, if I'm not already that.

What I need in my life is time, and I don't have that. What I do have to spend

my time doing is something that I don't enjoy, like U.S. history. I don't really care what happened in 1882 on December seventh, or what war took place and how many citizens died and who won, because that doesn't matter in life. That's past and you have to deal with the present.

The thing I strive most for is freedom and people can't understand that. My mom is very protective of me. She's uncomfortable with the idea that I'm growing up and that I'm gonna have a life of my own, and that I do already have a life of my own. I can make my own decisions. I am her closest friend, and that's good. But there are some things you just can't discuss with your mom.

She's paranoid about what I am doing, or what I have plans to do, or whether I'm telling the truth. I just can't talk to her anymore. She can't hold a conversation. All of a sudden you have to be arguing and I don't like to argue. I want my life to be full of peace.

If something is happening and I don't like it and I want it to stop, people are going to listen to me. Control is a major part of my life. If the situation gets a little annoying, people can't make a decision, somebody doesn't understand something and I do, I get very impatient. I want to control that way. It could be good or bad, I don't know, but it helps me.

Some people are very vulnerable and sensitive to what goes on around them; they feel like they don't have control. I have a couple of friends that have tried to kill themselves. They're going, "Oh, man, I am suicidal. I've got a problem, big. I can't help it." It's about losing control. I have thought about suicide, but I'm not the kind of person to do that. I guess that's why I'm a little indifferent, unemotional sometimes. A lot of things have happened that have caused me to just not want to be emotional anymore. If every little thing got me upset, I would be a nervous wreck right now. It's better to not give a shit, it's totally better.

People misunderstand me a lot of times. I probably come

off as really serious, bitter, pessimistic. It's just my outlook on life. I don't think of myself as a selfish person. I am so blessed, I mean, I am going to a wonderful school that costs almost as much as a college, I have wonderful parents, and I have a car. I'm really lucky, there's no doubt about that. But that doesn't mean I don't have the right to be bitter about some things. I hate hearing, "Things could be worse." I understand that, but that doesn't help a person when they're going through something, you know? I didn't choose the life I have now.

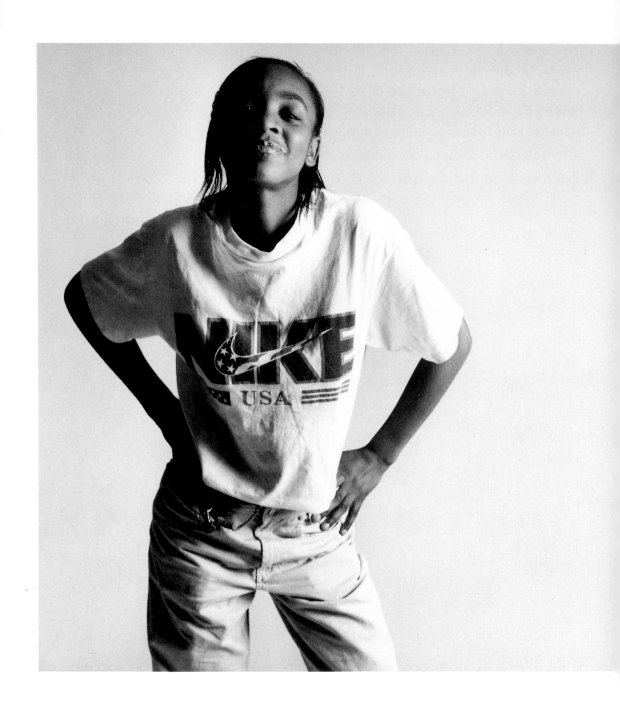

ANNIE, *16*

You gotta love yourself before you love anybody else. I'm just me. This is the way that God made me. If you don't like me, then you right out the door.

People that don't know me, they probably think I'm stupid, I don't go to school, I steal. They think I'm stupid enough to go sell their drugs. Sorry, sweetheart! They probably think they can get some butt from me, do it to me. They can't do none of the above because I see where they at and I don't want to be there.

The people selling drugs on the corner, they don't be trying to sell no crack to me. They know I'm not on drugs. I don't care what them other people are doing. I'm

going to do what I want to do. I know how to say, "No," or "Move, get away from me. Don't play with me." I know how to say that. I don't want to mess up my body like that. I've got goals. Nobody going to help me get there but me.

The only people on the continent that count are my family, because they are important in my life, and my teachers, because they are educating me. I have both of my parents in my house. My mom goes to work and she's got four kids. She comes home from a long day of work, and then she gotta clean up, she gotta cook. She's not on any drugs or nothing. She deals with the stress.

I feel pressures, everybody feels pressures, because that's life. I just think my problems out, or write my problems down, or open my mind to more things. I don't need to hit the weed or the bottle, I'm not trying to drink my life away. I'm not trying to forget about my problems; I'm trying to solve that problem. And if I can't solve that problem, I'm going to keep on steppin'— keep on going up that ladder, because I'm the only person that's gonna get me on top.

It's hard on us teenagers; we can get influenced like *that*. You gotta keep your head on straight. I have to keep reminding myself, "You know what you gotta do every morning: get up, go to school, go to work, or stay in the house and do your homework." I'm a real good person, you know? I don't need to be in all that mess. I'm trying to have a life here. I'm trying to have a front yard and a back porch by the time I'm thirty.

I don't have time for a boyfriend. He would just be in my way. I'm going to have to be worried about him some of the time, if he going outside to do some old drugs. He leave you, cheat on you, you know you going to be stressin' over him. Sorry, I don't need no extra problems right now. I'm trying to get my education, get to college, get my degree, get my money young. I want to be a pediatrician. I just have a lot of goals. If I could do it, believe me, I'm going to do it.

My greatest hope is for everybody to get along. They don't have to kill each other. I do not want no more people dead. They just keep bringing guns in this country and letting people buy them. Some of the people, they punks, or they get beat up and they want to go do something about it, they kids. They do some alcohol, or they might be just crazy sick in the brain. Got a gun in they hand and what they ready to do? That's a shame.

The government might just get tired of this community and drop a bomb on us, like they drop a bomb on Iraq or drop a bomb in Africa. I do not want nothing like that to happen. They might be like, "All of this stuff going on out there, let's wipe them out." If they tired of the killing, the drug selling, all of this extra stuff they don't need—just drop the bomb.

They don't even give us money in this community. There's just no money. They could make some more houses. They could clean the streets; these streets is *dirty!* We need money, we need paint, we could even hire people in the community to paint the buildings. They can give money to the people that sneak across the border and be on welfare and have better jobs than us. A person in this community, been here for nine, ten, eighteen years, and they still won't hire him.

I hope my life ends up being how I want it to be, even though I know it's not going to happen that way. I want it to be at least close. I'm going to probably have some children, and hopefully I'll have a husband, and a lot of money. Some people don't even think that they're going to see the age of twenty-five. I hope I do. I want to see my grandkids.

You have your whole life in front of you, if you allow it. If you try to stay in the good activities instead of negative activities. Just think about it, listen to your elders, go to school, get your education, be somebody. You can do anything if you let yourself go there.

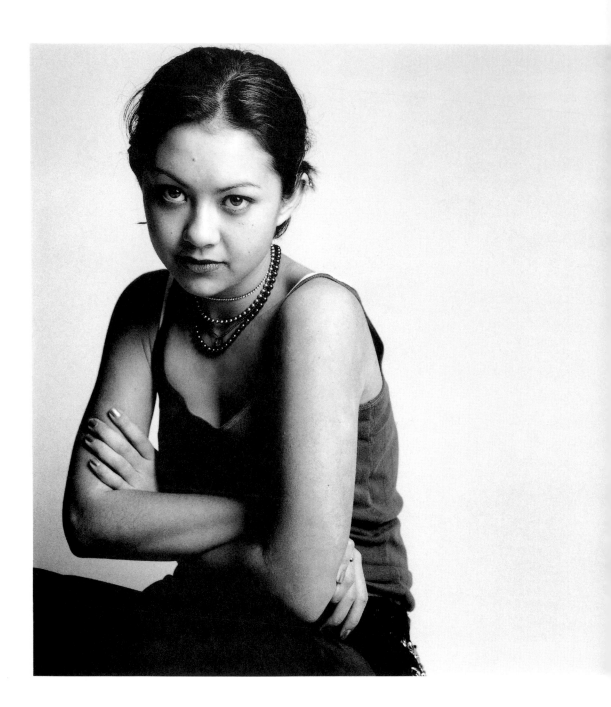

WHITNEY, *15*

I think guys are shocked by me. They meet me and think I'm this cool, tough, knows-what's-up kind of girl. But then they get to know me and I'm like this shy, weepy, silly girl. They get kind of shocked. Guys my age are silly anyway.

I would hate to be a boy, I would hate it so much. Guys are really shallow about sex. It sounds so cliché, but it is how they are. They let their testosterone get the better of them, which is kind of funny at times. Boys are confused. Maybe it's just me, maybe I have some strange complex about this, but don't you feel that guys in general aren't as levelheaded as girls? They just seem like they don't sit down and think

about things. Like, truly think, really clearly. I just don't understand how I could share sex with someone like that, who doesn't think.

I'm not one of those people who wears those damn shirts that say, "Girls Rule," or whatever. People should be treated equally. A lot of the time I get all righteous about things but I truly do not think that women are superior to men or vice versa. There is a difference. Women have so much power over so many things that guys couldn't even think about. I think women, especially today, know what they want.

People are pressured by society—they give you this impression of what's beautiful. They say, "This is how you're gonna get a boyfriend, this is how you'll be popular, this is how you'll get friends," and some people want that so bad. I don't find Cindy Crawford beautiful. I see her in magazines and I just see air. I really wonder what she thinks about. I mean, I don't know her, but to me, that's not beautiful. Most people's perception of beautiful is how a person looks, but beautiful to me is how a person is.

Popularity means nothing. It's the shallow people who are so not in touch with reality that strive on the popularity cycle. There's a whole section of people who, whether they're really cool people or not, they're classified as popular people because they dress that way and walk the walk and talk the talk, and they do their little parade around campus. They're the type of people who you talk to and the whole conversation they're looking around to see who's looking at them. I can't stand that.

You see all the sophomores, they all are like clones of each other. They all have the exact same jean shorts, the same Birkenstocks, the same little T-shirts, the same long blond hair. That's what they think is beautiful, and everyone wants to be beautiful. I guess that's all people expect from them. As far as how I dress, how I look, it's individual. My mother hates the way I dress. She says, "Take off those big clothes, you look like a boy!" But to me,

it's comfortable, it's how I choose to look. If I wanted to be a clone of those other girls, that's what I would do. But I don't.

Growing up in the nineties, everyone thinks they're overweight. I always feel like I'm overweight. I don't necessarily care, I eat so much food. If I become obese, then I'll start to worry about it. If you look around my school, there aren't any fat girls; there aren't any. People want attention and they'll do whatever they can to get it, even if it's negative attention. They'll starve themselves, they'll get sick, to please whoever. One of my good friends is ano-

rexic and she was in the hospital, weighing like seventy pounds. It's all because her dad was telling her every day that she was so fat. She was pressured by her *father* to lose that weight, I mean that's wrong in itself, but whether it's your father, your boy-friend, your best friend, or your dog, people get influenced.

I don't understand why people stress. It's not like I'm trying to impress anyone. All this teenage bullshit about dating and going steady and all that—it's everyone just practicing, practicing to find a match, practicing to find, supposedly, your soul mate. And if a soul mate does exist then why do you have to look beautiful for anyone?

I hate the way I personally am so unsatisfied with things. But I feel it's really shallow to say that I'm an unhappy person, because even though I am depressed sometimes, and even though I'm not one-hundred-percent cheery all the time, you seri-

ously cannot look at my life and say that I couldn't be happy. There are so many people in my generation that are walking around like, "I am the rebirth of Kurt Cobain and my life sucks so bad. I have so many problems; my BMW broke down yesterday." It's pathetic and I'm not going to play that game.

I find so many flaws with myself, it's abnormal. I think beauty comes with age. When a woman is older and has gone through so much and has learned so much and has so many personal stories, that's where beauty is. I know for a fact that I am just a little girl. Even though I've had many experiences with the real world and I've seen a lot of things, I am not a woman at this point. The title of a woman has to be achieved in some way.

JENIFER, *18*

Five of my friends have been sexually assaulted.
The first statistic I heard was one out of every three girls is raped or assaulted and I
completely believe that. I have been sexually assaulted and it was really scary, by
someone who was my age, actually, who I used to go out with. I was only sixteen. That
takes a long time to deal with, just in trusting other people again.

As far as sex goes, people always want to say it's the men who aren't respon-
sible, but I don't think that's always true. I have plenty of female friends who are not
responsible about sex. There are girls who do like sex and have it a lot. I have no
problem with sex if you are together with someone and you love that person. I find

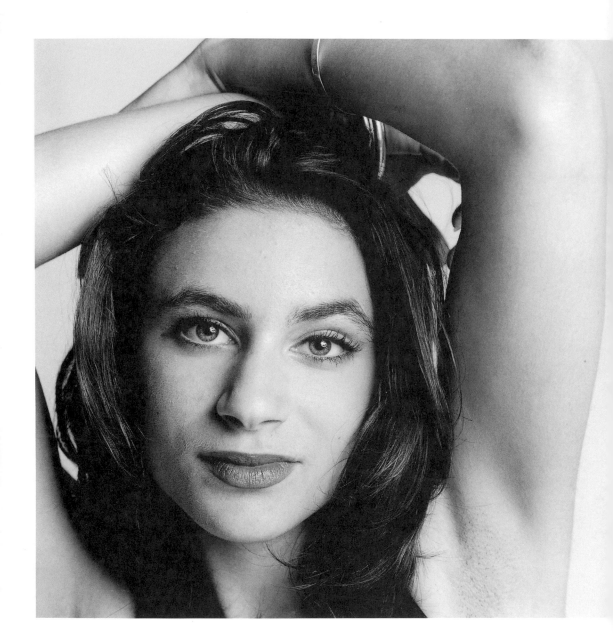

that a real personal thing. You are giving your whole self and it's like an exchange. When it's just thrown around it loses meaning. Not only that, but it's dangerous. Some guys are like that and some girls are like that; it works both ways.

The first person I slept with was my first love, and never, ever will I regret that. I can tell my kids, "I loved this man and it was a great experience for me," instead of, "Oh, he was some dude I met, just nothing." That's never changed for me, I hold that totally sacred. It can be a pure thing and it can be a dirty thing, and I'd much rather have it be pure than dirty.

The most important person to please is yourself. Which doesn't mean that everything else isn't important, but there is a balance that needs to happen. What I used to love to do is pretend that my problems weren't there and help someone else, which is fine, but your problems are still there. I would be there for other people and when I turned around no one was there for me. There was no give-and-take, it was only give, give, give. You can wear yourself out really fast. That was a big thing I learned: you have to put yourself somewhere in your list of things, you can't just pretend that you're not there.

I want to please my parents, but pleasing my parents is more about pleasing myself first. My parents are most likely to be pretty proud of me, just for being here. The grades, all that, you work for something and in return you get what you've worked for. The teachers are only there to help you along, to guide you.

When I was younger my parents always traveled, so they've been there, but not really. I've had to grow up that way. My mom and I have a close relationship. We get along a lot better than we used to. I tell her more, I confide in her. As far as my dad, it's hard because I don't know where to ally my feelings. He tries to play the father figure but he's not there. He didn't see the musical, which I directed; he didn't see "Evening of Dance"; he wasn't at the Humanities Festival; he's not there for a lot, and that hurts.

But he's also making the sacrifice for the family, to be working. I don't want to say I don't care, but I just don't want to deal with it.

My mom has always worked; in fact she supported us for six months last year when my dad lost his job. She makes more money than he does. She has very strong ideals and she's a very strong woman. My mom has a very good head for business. She knows how to do it and she's going to push it, but if no one's gonna listen, then they're gonna learn the hard way. That's the way I was brought up. I don't think that I should stay home and be a housewife and do nothing all day. I'm gonna support myself, definitely.

I know I'm going somewhere. I feel alive inside. There is so much out there to offer me. I'm looking forward to college, I know what I want to do. I have a motivation, I have a drive. For the most part, almost anything is in reach if you go for it.

REBECCA, *16*

I'm sixteen years old, my father's in jail, my mother's hooked on heroin, and I have to do everything by myself. I don't feel like I ever should have been here. My parents made a mistake of ever being together and bringing us into this world. My mom just had a baby, and I'm probably gonna have to take him. It's like I grew faster than my parents did. It seems like I'm the thirty-year-old and they're the sixteen-year-olds. The rest of the world don't see it that way; they still see me as a sixteen-year-old girl, not getting anywhere.

In eighth grade, I got kicked out of school because I came to school with a knife, which I know now was the stupidest thing, but back then it was like, "Oh, well,

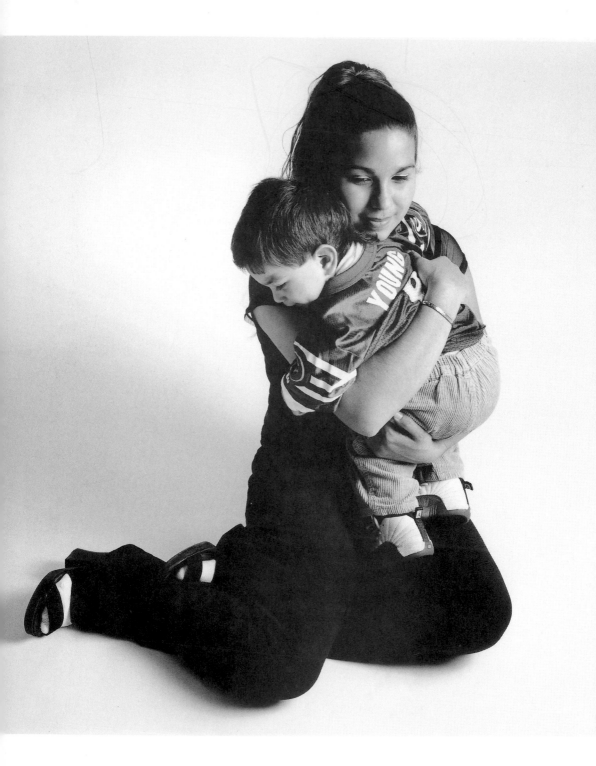

no big deal." I was trying to be cool. I was getting into gangs and violence. I just wanted to get away from everything. My friends, they were there for me. My family weren't. All they did was pressure me.

Then I got a boyfriend and he was in the gang. He was the top guy; everybody respected him. I was like, "Well, if that's my boyfriend then I have to support him." I wasn't thinking. I was just proud to be his girlfriend. He was a good-looking guy; that's all I thought about.

And then I got pregnant.

I was fourteen and I didn't know too much of anything. I knew I could get pregnant. I knew it was my responsibility, but I didn't know how to get birth control on my own and I didn't want to tell my father. I thought if my dad found out I was having sex, he would kill me. I didn't realize the consequences.

I didn't want to have an abortion at all. I've always felt alone, like I had nobody. I didn't feel so lonely once I was pregnant. It made me happy. I thought that he wanted a baby, too. I was like, "I love him. It's okay if I have his baby, everything will be fine, he'll support us." I thought he was going to take care of us.

At first, it was great. I was with the man I loved. We were renting a room from this lady we knew; it was like we were married. I had to have dinner ready when he got home and the house spotless. He was always going out, never spending any time with me, and I was getting more and more depressed. I was sitting at home by myself, I had a little baby growing inside my stomach. It seemed like he didn't care.

I couldn't talk to anybody because he was so jealous. When I would go to my prenatal checkups, he would yell at me, thinking I was out with some other guys. He was the one that was always going out, doing things, lying to me. I was miserable. Eventually, I got so sick of it, I just had to get out of there. I moved in with my grandma.

I was due any day and I heard that my boyfriend was with another girl. That totally broke my heart. He didn't even know our son was born until he was two weeks old. I called and I was like, "Well, you have a little boy." Two months went by. Finally, he came to visit one day. He held the baby like it was a dog or something; he couldn't even hold him next to him. He stayed like five minutes.

Later he got arrested and was deported back to Mexico. I don't hear anything from him. I realized, you know, he was no good anyways. How long would that have lasted? He made my life miserable.

I didn't think about all the things I was going to go through, I didn't think about all the hard things. When that baby's crying, that baby doesn't want anybody but you, the mommy. You have to support that baby, you have to make sure he has all three meals every day, you have to make sure he has shoes, you have to do all that stuff. School is the biggest stress. My son was just sick for a week and I have no idea what's going on in any of my classes because I missed three days of school. Every minute of your life is with that baby.

I don't regret my son at all. He's the most precious thing in the world to me, but if I knew I could have this exact baby later, then maybe I would wait. I don't know. Sometimes I say I would definitely have waited, so I could have got things done and been through everything, but I can't imagine my life without my son now. I can't imagine what I would be doing. In a way, he saved my life, because if I didn't get pregnant with him, I probably would have still been in the gangs, shot dead somewhere.

I have no idea where my life is going, but I know I have to finish high school. I want to graduate. I want to go to college. I'm working and I'm supporting my son myself. I'm not depending on anybody else. It's gonna be hard and long, but I'm gonna do it. It's going to happen. Maybe not today or tomorrow, but it's going to happen.

Through my whole life I have just wanted to die and not be here. My worst fear is having my son grow up like that. I don't want him to worry about all that stuff. I try to be happy, with my baby and everything, but I am still depressed. I try to push it back because I don't want to face it. I still want to be a little girl.

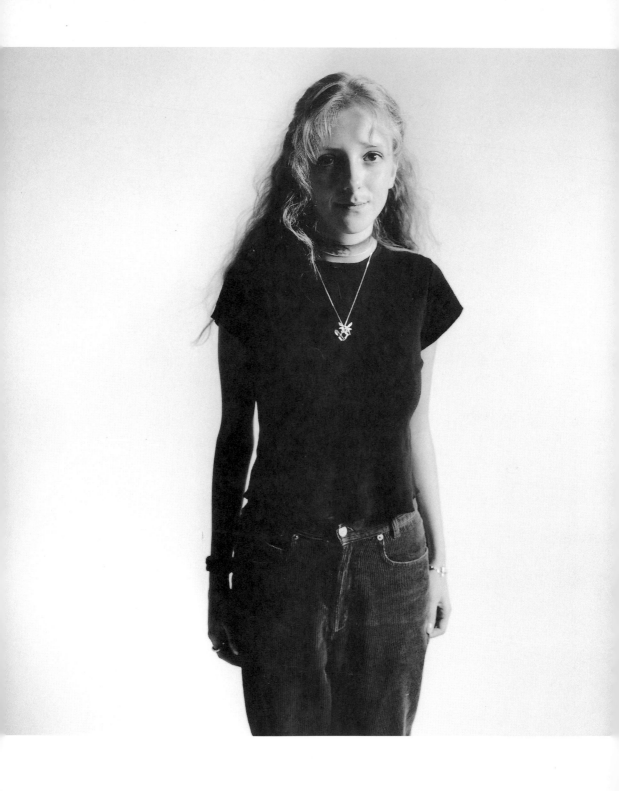

JENNIFER, *17*

I'm an abnormal teenage girl, I really feel I'm not the norm. I don't feel like I'm beautiful but I feel fine with how I look. I just look kind of weird or unique, maybe, but I don't feel like the standard beauty girl, and that's okay with me. My parents are so encouraging, I owe that to why I have so much confidence. I'm so thin naturally, this is natural; I eat all the time. Most girls have a huge problem with weight; they are always so worried about it. I'd actually prefer to gain weight because I don't like people to look at me and think I'm anorexic. To me, anorexia represents being weak. I've had friends who were anorexic. Ironically, they want to look like me, and I think I'm too thin.

I heard somewhere that all people who are popular in high school become losers later on, and I believe it. People who always want people to look at them, they're really obnoxious, girls particularly. They dumb down their personalities and talk stupid; they're just concerned about guys and their clothes and what they look like. It's not as if that's not important to me, too, but it's not my focus.

There is some bizarre need in girls to always want to have a boyfriend and to change their personality for guys, which means letting him be smarter, laughing at his jokes, and doing what he wants to do. And there's a big cross section of guys who like a girl to be dumb and insecure, because they're easier to control. They just want a good time, a bracelet girlfriend, that's what I call it. I've felt that way sometimes, "This is my blonde, instant girlfriend, exhibit A." I'm not actually a real person. I get out of those situations really quickly.

My parents have a great relationship so I expect a lot from the people I'm dating. I think you mimic the relationship between your parents. I have pretty high standards and it's because of them. I am trying to be stronger. I've looked back on my relationships with guys and I'm like, "I wasn't strong enough. I should have been more direct." The past couple of people I've dated, I have been more direct. And it means that after two dates they don't want to hang out with me anymore.

I'm a late bloomer with guys. I'm connected mind, spirit, and body. You can't just have my body and that's it. I've never been that type of person, which is, I'd say, unusual for teenagers because a lot of people just fuck around right now and it's cool. Unless I like the guy's personality and I know he respects me and I trust him, there's no way I'm going to do anything with him, or even pursue him as a relationship.

You hear from these girls that guys say, "If you do it, I'll love you." I don't even understand that mentality, I'm like, what are you

talking about? I would never fall for that. Guys can just feel it off me, that it's not a "one night, thank you, ma'am, see you later" deal. I'd be devastated if that happened to me. If I had sex with someone who didn't care about me, it would just kill me.

I'm a strong woman but I'm not anti-man. I don't feel like doing to men what they have always done to women: put women in a specific place, saying, "You're only a mother, you have no intellectual capabilities, you're supposed to be weak, passive, I'm going to save you." It's just not true. I try to change it with myself; I don't let anyone treat me that way, as if I'm a weak female that needs to be saved.

Girls are repressed in like a hundred million different ways. I'm fighting against that all the time. If you state your opinion, people think you're a bitch. Hillary Clinton reminds me of that. People think she's a bitch and I think it's specifically because she is a woman. People don't like her being powerful, just because of her gender.

I don't mind people who are introverted, but I most like people who are extroverted, loud, and obnoxious. I'm pretty forceful, almost a bitch, but in a good way, not in a mean way. I just express how I feel, which I'm not sure most girls do, especially to guys, but I don't give a shit.

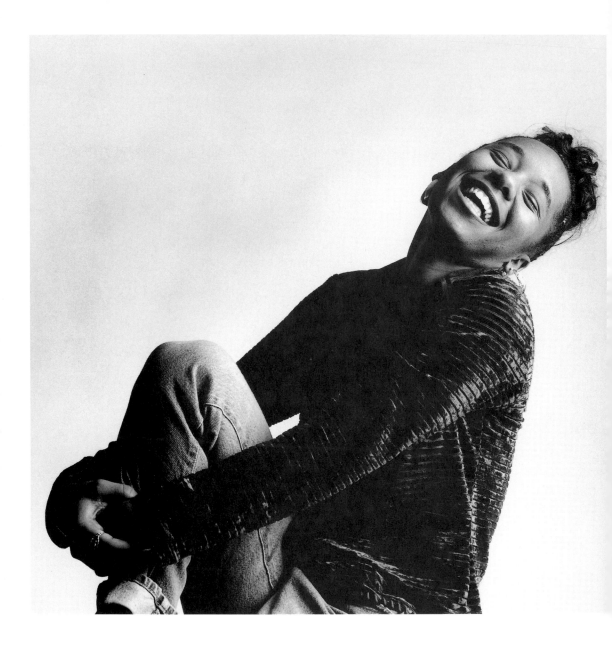

CHABLIS, *17*

I'm gonna write a book by the time I'm twenty-five, about my whole life. Everything I can remember, from my mother's addiction and what I had to go through, to my high school years, sexual life, of course, girlfriends and boyfriends, and cars and probably college. And by then I'll probably have a baby, so that'll be in there. If I have a husband or a boyfriend, I hope I don't never fall for that silly stuff, but, you know, that's all gonna be in there. I wanna write it by the time I get a career, so I can just be like, "And now I am successful."

My mother used to be on drugs real bad for a while, and my father. That's lot of the reason I don't do it. I went through a lot of stuff, you know, the average. It

wasn't like nothin'. It was the same for everybody parents, seem like everybody mother used to be on crack. You deal with the basics—the household stuff, the police raids, living with your grandparents, needing money, all that. And after a million things, they better. We came a long way.

I never been one of those people that gets pressured into doing nothing. Sex, though, I followed everybody else. I have got pregnant before. I knew what I was doing—we both knew what we was doing, we just didn't know *that* was gonna happen. That one was a love baby, a passionate baby. That just happened.

I had an abortion. I wasn't ready for no kids. I would not have no kids till about twenty-two, at least. I would go for another abortion. All of my friends just about have had an abortion. Nobody don't want no kids. A baby just stop your whole everything. There's a will and a way to do everything, but damn, that's gonna slow you down. Can't be like, "Oh, I'm going outside." Who's gonna watch the baby? "Ooh, I'm about to buy me some shoes." Your baby needs some diapers. Hell, no! I am not going through that. When I'm ready to go outside, I'm going. When I need some shoes, I'm gonna go buy me some shoes.

I didn't have one of those baby fathers who flaked out like, "Bitch, that ain't my baby," or nothing like that. He went through everything. Every time I went to the doctor he was there. He wasn't one of those stupid ones. He would've literally got his ass whipped if he would have tried to play me like that.

He didn't want to get rid of it, but he didn't have no job; he didn't have nothing. I'm like, "You're so stupid. What do I look like? Producing something when you don't have anything, you don't even want to go to college." So he wants the baby to be his cop-out, like, "Oh, I can't go to school 'cause I gotta work." Uh-uh. He was like, "If you kill this baby, I'm not gonna be your boyfriend no more." I was like, "I don't care." I let him go. "Bye!" I dumped that clown.

I don't pay boys that much attention. I tell them, "Don't

think I'm gonna be talking to only you." I'm too young, I'm only seventeen. I have a whole lifetime ahead of me. I'm not focused on no boy right now. It's sort of a distraction. You be thinking about him when you supposed to be doing your homework, be at work wondering, "Who he with? Why is he in the car with her?" I do not have time for none of that.

I'm ready to grow up, but then I'm not. When you're young, your parents take care of you. Sometimes they'll get on your nerves for you to get a job, but when you're older, there's no other choice. I like being a teenager. I like the free stuff, the free rent, and things that you don't think about till you get older. The difference is basically responsibility. Same cycle over, you just have different things to do. It's rent and bills and insurance, when at first it was just the school dance and lunch money.

I'd prefer to live day by day than live for the future. I think everything is a lost hope. Everything changes so fast, you don't know how it's gonna be next year. I don't really have no fears but death. I don't wanna die. No time young, that's all. If I'm like forty-five or older, okay, maybe. But I wanna at least make it to thirty. I pray sometimes at night, when things real bad. Or just 'cause I woke up the next morning, I just thank that I made it to the next day.

When someone die, you always be hurt over that. It's a common thing, in this type of community, every day. But I have so many people that die it don't make no sense. At least ten people that I have been close to have died. About two or three family members, and a lot of friends. I mean, you just think about it for a minute, then it's gone. You can't dwell on it, 'cause it's not gonna change nothing. So you just gotta keep going, day by day. Ain't no way to stop it.

I inspire myself. I don't listen to nobody. I may take a suggestion and try to put that one together with mine, but I won't never just take another person's advice. Not even my mother. You gotta learn on your own.

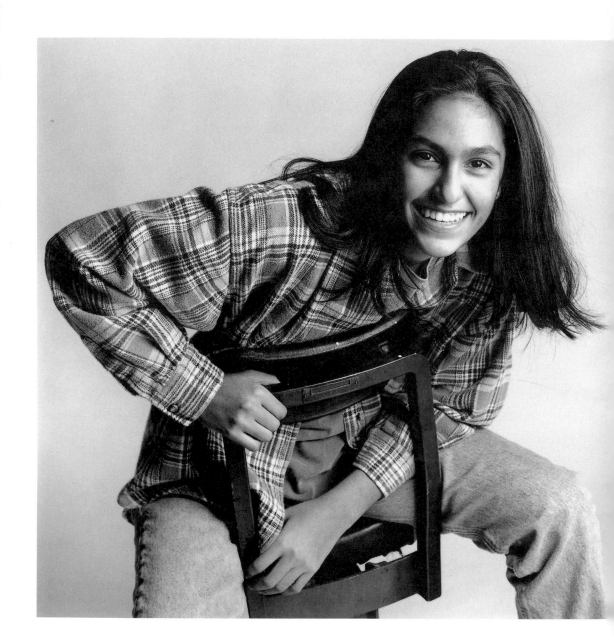

MARTITA, *17*

I think I'm beautiful, 'cause my girlfriend told me I am. I actually like my body pretty well. I'm fit, I'm in good condition. I can do over one hundred push-ups on my knuckles, so I'm pretty cool! The only time I worry about my weight is when I eat a big thing of chocolate-fudge-brownie ice cream all in one sitting. Then I feel kind of bad. But I don't ever just eat lettuce for breakfast, lunch, and dinner to lose weight. Actually, I shocked my doctor. He asked me, "What do you think about your weight?" And I said, "I'm okay." He had to leave the room. He went to my mom and was like, "Oh my God." He said I was the first teenager who ever told him that.

The whole glamorous look, I'm not into that. I don't dress like a girl. I don't wear dresses, I don't wear tight clothes. It's restrictive, it's not comfortable. I was never a little girl; I was a tomboy. I was special, I got to hang out with all the guys and do fun stuff. Now, I think guys are dumb. They're completely ruled by testosterone. They try and be tough and cool, and they're not. I've never in my life been attracted to a guy.

I'm a dyke. Eighth grade is when I started figuring it out. I had a crush on a good friend and I didn't understand why I was so into our friendship. I found out that she was moving away, and I was not going to see her again, and I got totally depressed. It hit me that I was in love with her.

I didn't talk to anybody for a long time. I had the opportunity to talk to people right from the beginning. There were teachers at my school who were gay, so I knew that door was open. But once I started thinking about it and I realized that that's what it was, I didn't take that opportunity. I didn't come out to anybody until I was a sophomore in high school. I was fifteen. That was after two years of being very, very depressed and not being able to talk to anybody about anything, not feeling comfortable even talking to my friends about normal things. I thought that they would see through me. They'd be talking about guys and I wouldn't say anything.

I came out to one person, my best friend. Even then, it was hard for me to actually say it. That was the first time I ever said it out loud: "I'm gay." I let down my guard, just for that one moment. Then I was like, "Jesus, I should have done this ages ago!" I started coming out to other friends. I told like five people within a two-week period.

I came out to my family a year and a half ago. It was scary. I didn't know what to do; I had no idea what I was doing. I had been going out with my girlfriend, I had been just leaving the house and disappearing for hours. They didn't know where I was going because I had no idea what to tell them. My mom was finally like,

"Tell me where you've been going and who you've been going out with or I'm going to ground you—forever!" I was like, "Fine, you want to know who I've been going out with? My girlfriend."

I asked her not to tell my dad because I was afraid of how he would react. A couple of days later she said she had to tell him because she couldn't handle it by herself, which meant that she was really upset about it, and that kind of freaked me out. My dad took me out on a drive. I was so afraid that he was going to drop me off by the side of the highway and just leave. I didn't think he would accept me. We sat and talked, and he cried. I had never seen him cry before. His dad died the year before and he didn't cry then, but he cried when he found out I was gay. That crushed me.

My parents are pretty caring people; they always tell me how much they love me, and I was afraid this was going to be it, that they were going to draw the line. They didn't threaten to kick me out or anything, they didn't get mad at me, but they were visibly upset by it.

Occasionally, I've made a joke with my mom, like, "You don't have to worry about me getting pregnant!" I don't talk about anything like that with my dad. There's a wall there. Which is okay, because I never really talked about stuff like that with my parents anyway. My dad said that he was just worried about me because I was going to have a hard time. All he wants is to make my life easy; that's why he works so hard, so that he can give me a good life. Now he thinks I'm going to have terrible things happen to me.

Growing up close to San Francisco, it's been easier for me to feel that I'm accepted somewhere, that not everybody in the world hates me. I mean, I hope not. There's parts of the country where if you don't fit into the mold, you get your ass kicked. I don't like to think that every time I walk down the street I'm going to get beat up or shouted at. I haven't really had a bad experience. I've walked down the street in San Francisco holding my girlfriend's hand and people don't even look.

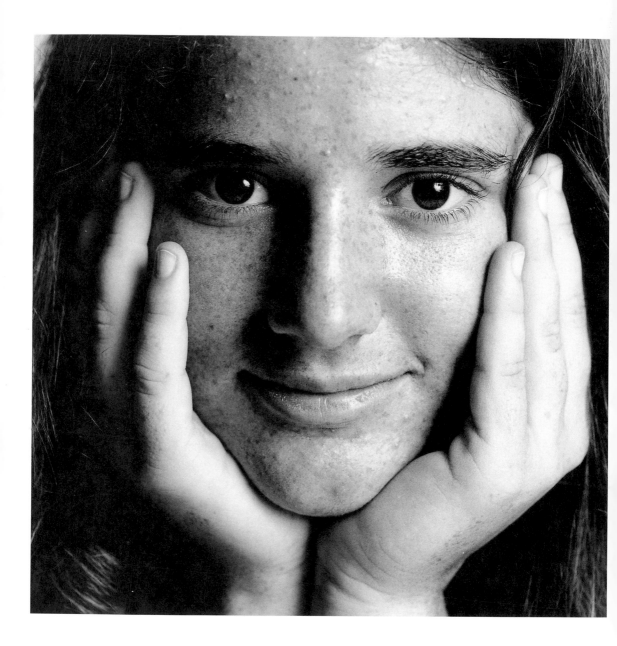

LESLIE, *16*

I had done so well in elementary school, I got As and I had a lot of friends. Then I went to middle school, and there was a girl who ridiculed me all the time, and I had no friends, and people made fun of how I dressed. It led to a period where I had to question myself all the time; it was like, "What am I doing here, what's happening?"

People would call me weird because I didn't talk very much, I would keep my face down, I didn't look at people in the hall, I didn't dress like anybody else. They would say, "You're such a weirdo," and I would think, "Why are they calling me that?" Now, I see so many people at school who seem like they're just carbon copies and

I think it's good to be weird. It's good that I am not in a group of people where I need to like the same music, wear the same clothes, have the same hairstyle. So, I like being weird.

Popularity is about zero on my list. I love my friends, they're very important, but I don't need to be the queen of the heap. I would like to be attractive because I am very interested in finding a relationship, and I feel if I work hard on my looks it will help. I exercise a lot. Sometimes I want to feel sexy. When I've worked out I feel more confidence. I'd like to look good first and then they might be more open to talking to me, and then the relationship part comes in.

I tend to not say things to guys I'm interested in because I think they're going to see through me; they're going to *know.*

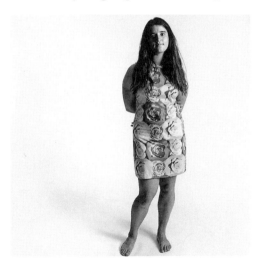

I don't want them to know, I won't show them myself. I feel vulnerable when I do that, I feel transparent. The guy who I am pursuing now, still, every time I go up to him, I get butterflies. I think, "He's going to know I like him, I don't want him to know!" Then I would feel I've lost control. I want to do it on my own time.

One guy I dated—I only went out with him once—he told me, "You're exactly how a girl should be." And I asked him what that meant and he said, "You're gentle, and you listen, and you're kind, the way girls should be." I didn't like being categorized like that. I didn't like being defined like that. Since I've been raised to be polite, I didn't yell, "Fuck you!"—but I felt like it. I wanted to punch his lights out.

My mom has a whole shelf of books about understanding teenage girls—how girls always get shy and they're ignored in the classroom. I never feel ignored in the classroom, but sometimes I have to shout to make myself heard. I don't tend to do it very often, so whenever I do say what I have to say, I really mean it. I don't know if other girls feel as I do, but I start to say something sometimes in English class and I get drowned out, not because the boys got called on but because they speak louder. I try to reevaluate what I have to say: Is it worth saying? If I feel I have something important to say, as soon as the question is asked, I yell out the answer so I don't get cut off in the middle.

I am expected to be no-nonsense most of the time, at least with my parents. When they broke the news of their separation, they said they were counting on me to deal with it as I always do, strongly and reasonably. It's hard to get upset, especially around my dad, because he's like, "You are so clear-headed, why are you allowing yourself to get confused?" I have a vulnerable side, but I am reluctant to expose it. Since their separation, I have gained respect for them for not staying in a bad relationship that doesn't please either of them, and I've lost a little respect for them not going to fix it years and years and years ago when they might have been able to. I'd still like them to get back together. But listening to my mom, she feels so much better now, she feels free to do things that she never would when my dad was home.

My relationship individually with my parents has improved since Dad left. When we have dinner together, we always start some discussion that takes two hours. Since Dad's a historian, he gets talking about historical issues and things he's writing about, and I have a great time. We get together for coffee, play cards, play dominos, talk about World War II—I love history; it's one of my best subjects.

Occasionally, my parents will say, "You shouldn't do this or that because it's not ladylike," and I hate hearing that. I don't give

a damn about being ladylike. They say, "That's the way it is, that's how people perceive you." And I keep thinking, "Well, maybe those people aren't right." I don't want to be a slob, but I don't want to be deferential. I'd like to do what I please, whatever that happens to be.

I fear being completely alone all my life or being locked into something that I don't want to do. My mom got married young, when she was twenty-two, and she never lived by herself or really had a career. She said she didn't know who she was when she got married and that was one of the problems with her marriage. Dad is eight years older than she is, and he'd been in the army and in various relationships and he knew what he wanted, but she didn't. I want to have a career before I settle down. I want to live by myself, have a job, make some money. It will help me figure out who I am. I don't want to rush into anything, I want to know what I want first and then act. I hope to always remember what I want to do.

MITSUKO, *16*

Some days, some days I just crash really bad. I feel hopeless; the confusion's more amplified. I used to more often, but now I don't get as depressed, I don't know why. Probably because I know more now. It's better than it was in ninth grade, tenth grade. It was horrible. Just hopeless, just pure hopelessness, just like the purest hopelessness that you can imagine, every day. Extreme boredom or really bad depression, which I've kind of grown out of, but it still kind of sits. It's amazing because I thought I'd never get out of it, I thought I'd kill myself before I got out of it. What I've seen from two years ago and now—just the confusion and depression that you go through at this age.

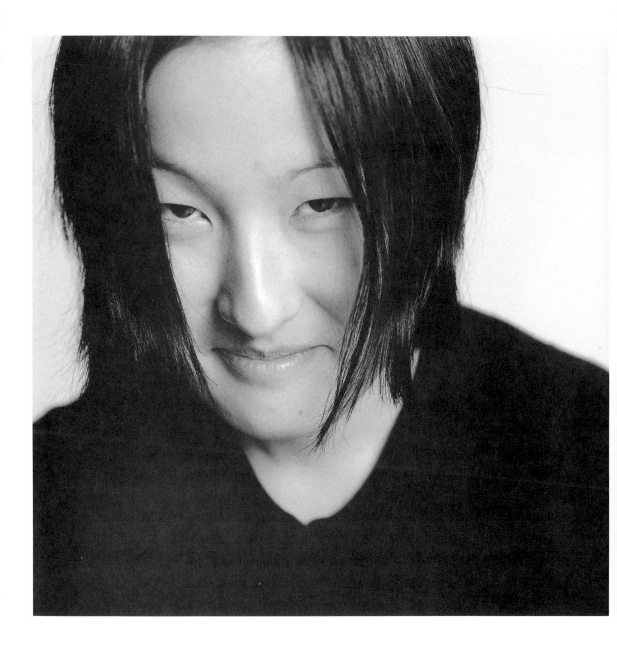

I don't know what to do. I don't know what to feel about my feelings because I haven't felt these feelings before in my life, maybe in my past life, but this is my life right now and I don't know what the hell is going on. It's sucky, because there's no handbook. You just have to make mistakes to get more experience.

Love is like one of the weirdest things a person can do. It hurts, it's bad, but it makes you feel more living and more here. There is hopelessness in it because there's nothing you can do to make it perfect. I guess true love is like a total accepting. If you haven't gotten to the point where you understand yourself, then love is harder. It's so weird because the person you're involved with, you kind of think that you're going to be with them forever, like, "That guy's the one!" And then, if that doesn't work out, oh my gosh, it's so weird. You get these expectations in your head so it's really bad when you crash down.

I don't like how it's all cool to be bi. It's trendy. It's like Starbucks; it's getting commercialized. People should just leave it alone. There haven't been any girls that I've been attracted to. I see girls on the street and in magazines; sometimes I'm attracted to them, but I still don't know. I'm not that experienced yet. Women who say, "Men are stupid," can just be overreacting, even though men *are* stupid. We're more in touch with ourselves and men are more repressed, they hold in their emotions more.

I want freedom, emotionally and physically. Being depressed and confused is kind of good, in a way. I like it, I feel comfy in it. Strange—it's like masochism. But I do kinda want to be happy. I want the best of both worlds. I don't want to be a happy, giggle, giggle person and I don't want to be a miserable person. I just want to be in the middle. I want to know what my feelings are telling me, to be able to read them. I want to be grounded and I want to know what I'm feeling.

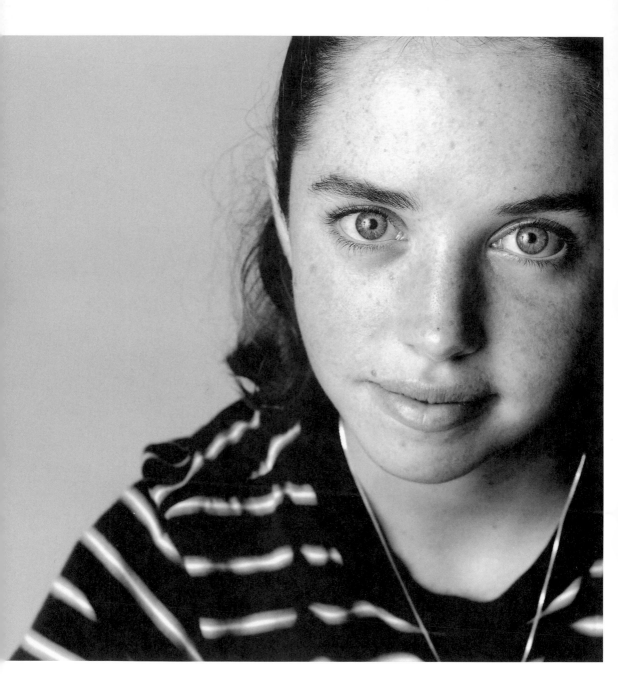

ATHENA, *15*

I don't *know* who I am. I used to really struggle with it and stay up nights. I was really trying to *find* myself or whatever. But I never was able to. I kind of just let that go. I believe in fate, there's a certain plan for us, but I'm not sure what that is. I think God is like everywhere. I don't think of a big old man in the sky. God can just be a presence, a reason why we are here. I think a lot of teenagers have lost any faith they had in anything.

I consider myself an individual. Once you're part of a group, you have to do what the group does and you can't make your own choices anymore. I don't like pressure to do drugs, or have sex or anything. I've been trying to stay out of that stuff.

There's addiction on both sides of my family, so I know I'm susceptible to it. My mom is a recovering alcoholic. She's been sober nine years. I've gone to AA meetings with her since I was seven and that has taught me a lot. I think people would think twice if they knew what could happen, if they realized it was just a dead-end life. I mean, you have nowhere to go. Once you're addicted, you're addicted. I don't want to be like that.

Me and my mom have always been close, but now our relationship is the best it's ever been. She's really understanding of me being a teenager, because she had a rough teenage time. I feel like she relates to me, and she understands me more than anyone else in my life. My parents have been divorced since I was three. I live with my dad, but I never see him. He works really early in the morning until really late at night. I see my stepmom more than anyone else.

My stepmom and I used to be close before I got to high school. I felt like I was going to have great teenage years with her because I thought she understood me. But when I became a high schooler, she became like afraid of me, afraid of what I could get into, worried that I would do bad things or that I would get hurt. Whenever I ask to do something with my friends, it's a struggle. She never wants to say "yes," she always thinks "no" right away. She should trust me, I've been paying attention. I know what's right and what's wrong. I know how to make my own decisions. Keeping me from going out there and being who I wanna be is really making me anxious.

My brothers got a lot more freedom; they're a lot more strict with me. They even told me that I have less freedoms because I'm a girl, because more could happen to me. It sounds kind of ridiculous to me. I'm a girl, but I'm not stupid, you know?

I believe in women. I believe that we have a lot of things to share with the world. I think that women have a lot more power

than they choose to accept. There's a lot of things I want to do. I'm going to be something. My whole life is in front of me.

My brother really changed how I look at my life. He was born with a congenital cyst in his brain, and it was totally harmless until, for some reason, he had a seizure. So they did an operation. They went through the top of his skull and removed it.

Before the operation he had no symptoms at all. He was totally normal and healthy. And then, all of a sudden, he was this helpless person. It was hard for me; I mean, he's my big brother. On the day he had the seizure, my mom said she'd meet me at the hospital and she wanted me to go in the ambulance. She told me I had to be the strong one. I was like, "Whoa!" I wasn't ready for that, I was scared. She was like, "You need to be strong for him because you're his best friend."

It made me stop and think. I really, really love my brother, and I didn't know that before. I told him I loved him then for one of the first times in my life.

Right after the surgery, I would see my friends at school, and the problems I thought were really important just seemed really not important. Even though it may seem terrible to you and it's the worst thing in the world that some guy doesn't like you, and the kind of stuff that seems to ruin your whole life, it could be worse. If you look around, anyone you know could get in an accident one day and you'd never see them again. It changes how you look at people. Our time is so limited, it seems like we should spend it being nice to each other and learning good things from each other instead of making ourselves miserable.

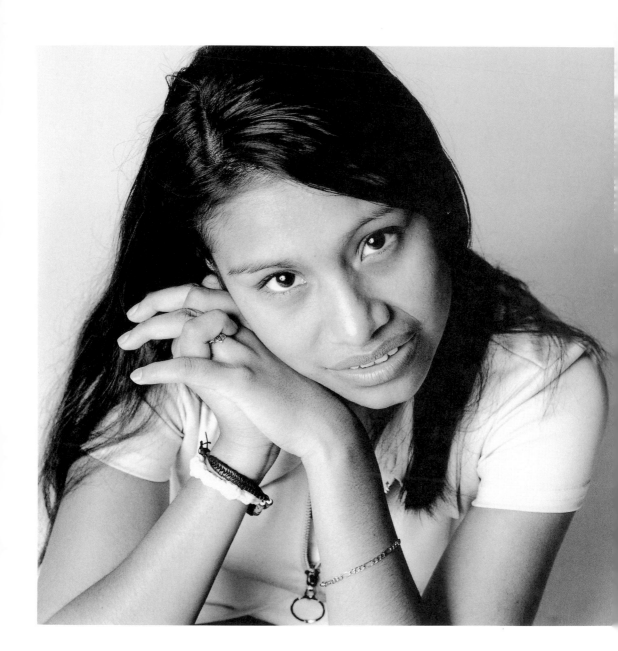

ALMA, *15*

I look at the whole picture, and I'm not beautiful. I just don't like myself and I don't like how I look. I would like to be like my mom's family. They're all white; they have green or blue eyes, blond hair. I would like to be like them.

To me, friendship is beautiful. Your friends, they're always going to be there for you, if they are really your friends. And you're going to be there for them, too. You're not going to have friends just by being popular and pretty and having clothes and all that. You're going to have your friends because of who you are.

With my friends, I can act crazy and they won't say nothing. But with my par-

ents, it's different. I have to calm down and act my age. My dad is really strict. He says I can't have a boyfriend until I'm sixteen. I still do, though! The only one who knows is my mom; she doesn't say anything to my dad. I can't tell him. He won't let me go out, not a lot. I have to behave myself with guys. He doesn't let me have a boyfriend because he wants me to study. He wants me to get a good career. He's like, "I couldn't make it, so you could make it. I want you to study and be somebody. I don't want you to

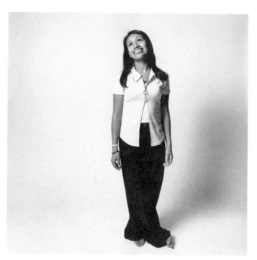

just get married and have kids. I want you to be somebody."

Guys don't go for the old-fashioned way. They're weird. It's hard to understand them. For me, a relationship is to know each other. Not just have sex and kiss and not talk to each other. And that's what they expect, most of them, to just have sex. No, for me, that's the wrong way to go. Your boyfriend, he'll be like, "If you love me, you will do it." That's not love, not from him. He just wants your body and that's all. If he really loves you, he won't make you do nothing if you don't want to.

You don't just say no; sometimes you have to explain to them. Most of them, they just want to have this girl. But when they wanna get married, they wanna get married with a virgin girl. And I'm like, "Do you get the picture? You want to get married with a virgin girl, and you're doing it and you don't care." It doesn't matter for guys. But for girls it's a really important thing. I want to be a virgin when I get married.

My friend, she did it with a guy who didn't care. They had

sex, and then he left. He just left a note; he never said anything. She even told me, "If you don't want to do it, don't do it. You will regret it some day." She told us a lot of stuff. She doesn't want us to go through the same thing that she had to go through.

I think that most of the girls that get pregnant at our age are Latin. They have too many problems in their house. I mean, I have problems in my house, but it's not like I'm going to go and do it and get pregnant. Then you just have the kid and you have to take care of it. I do want kids, but I want to have them when I'm ready to have them. I want to have something to give them. I thought that what I would like to do, if I ever get married, is to adopt a black kid. People are racist against them and they're just little kids. They don't have a mom and a dad. I want to give them something.

I hear a lot of racist comments against Mexicans; they'll say so many things, like, "Go back to your country." That makes me sad. I see no difference. I mean, for me, everybody is the same, and the color doesn't mean nothing.

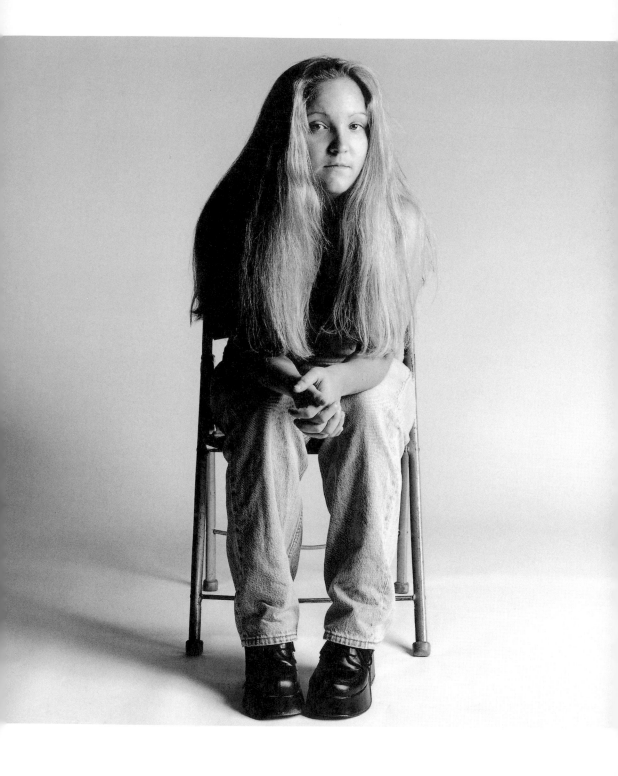

CANDICE, 17

I've had a lot of people close to me die. My dad died when I was in seventh grade. I have to do things without his help and I'm stronger that way. He had cancer. He had treatments for about two years, and he lived longer than he was supposed to. I was closer to him than my mom, so I totally shut down at that time. I shut off from everyone; I didn't care about anything. I still think about him all the time.

My relationship with my mom has changed; we built a better relationship. We talk a lot, but I don't tell her everything. I don't lie to her; it's really cool that I don't have to. I was "Daddy's little girl," and after he died, she felt like she'd be the witch

if she didn't let me do stuff and that we would never become friends. Anything I wanted to do, she'd let me do, within reason. She does trust me, but she worries. She's always up when I get home, she knows where I am when I'm out.

My mom works hard in everything. She has three kids and she's a single mother and she works hard every day. We have everything that we want. We own a business. If you work hard you can do most anything—that's what she does.

My relationships with people are the best aspect of my life. My close friends, they know me, they know who I am. I want to talk to those people every day and see them every day. I cheerleaded for a year and I hung out with these girls that fit the stereotype of a cheerleader. They would blow you off for a guy, and I hated it. The friends I have now are real. Guys expect girls to be really flirty and sit on their laps and gloat over everything they do and tell them how cute they are. When I'm not seeing someone, I like myself better.

Most of my friends are always saying they need to lose weight. It's for boys. And for clothes and, I don't know, everything. Models in magazines are always really thin, so that's what everyone seems to like. It's everywhere. Even Barbie. You play with Barbie and she's perfect-looking. No one has her body. She's really, really tall, and her boobs are enormous. They did her up to life size, and her waist was something like fourteen inches. That's sick. But, of course, she looks good in all her clothes.

Weight has been a big thing. I've been on a diet since I was in fourth grade. My mom says I probably always will be. Last year at this time, I probably weighed twenty-five pounds more. I'm still not content with my body, but things fit me better and I don't get called names anymore. If someone's going to put you down that's the first thing they go to, if you are overweight. Last year, there was this guy who was really mean to me; he'd always call me "fat." I'd go home and cry about it, even stay home from school

to avoid it for one day. When you're overweight, you know it and you don't need to be told it by someone else.

I used to obsess over food and exercising. I was on a really strict diet, my mom helped me, but I took it too far. I was wondering why my hair was falling out a lot, not in chunks or anything, but it used to be a lot thicker. I love my hair! I didn't even want to brush it because it was falling out. And my nails got those little deposits on them because I never drank milk; milk was the fattiest thing. I was scared, I didn't know what was going on. I'd feel hungry and I'd want something to eat, and I'd eat salads and pickles and things with zero calories that tasted like nothing. I totally deprived myself of everything. You can't live on lettuce and celery sticks. I went to the doctor, and I was suffering from malnutrition.

I totally love food and I know that I love food, but I do have a problem with it. When I'm stressed out and I'm writing a paper at twelve o'clock at night, that's what I'll do, I'll eat. And I won't grab a banana. Food is comforting, sometimes it really is. I know so many people with eating disorders. You could even say what I had was an eating disorder. Food is a problem, an issue, if you can't go through life and just eat meals, because you need to eat to survive. You can't not eat.

I care about the way that I look. It seems like you get so much farther, because people are really superficial that way. People judge you on like the first eleven seconds that they see you, so if you look good, or are attractive at least, then it seems people give you more of a chance. I don't think I'm ugly, but I don't think I'm *beautiful* on the outside. The person that I am on the inside that I see, and that very few other people see, is beautiful. I'm really loving, and that's part of being beautiful. The inside is more important, but getting there is kind of hard sometimes.

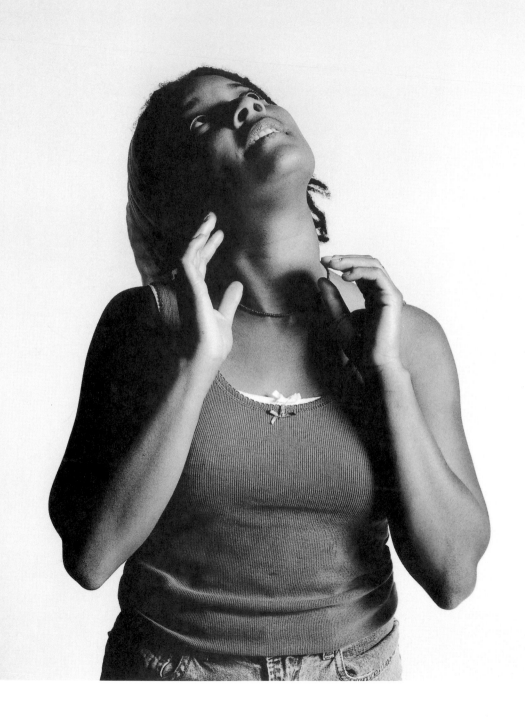

Amron, *17*

I feel strong when I wake up in the morning. I feel strong because it's a new day and I expect the sun to come up and it's beautiful. I'm never disappointed with the way the sky looks. I feel strong because I have people who love me, and I love myself for sure.

I'm going to be eighteen soon and I'm pretty nervous. I don't want to be responsible as a woman would be, in the "fast lane." It's tough to be a teenager because you're conflicting. This is the time for the most growth, the biggest transition happens between twelve and twenty. There's pressure to be adult, pressure to be child, pressure to be your own person because you tend to go away from your par-

ents. You have to live with them until you can fend for yourself, but I think there needs to be more of a transition period. Me, I don't feel like I have enough of one. I'd really like more freedom to be irresponsible.

We want to be ourselves, but we want to fit in. We want to be independent and self-sufficient but we don't want to have to do a lot of work. We want to feel good about ourselves, but it's hard to do that if you don't feel supported by your peers or your friends or your family. We want to be accepting, but it's tough sometimes to put your neck out there. Since we're in this developing stage, it's hard to predict us.

I was hurt when the boy I loved started falling into drugs and bad stuff. I felt responsible. I felt like I wanted to make it better for him. Not that it was my fault, but I was the one thinking. He wasn't thinking very well at all. He wasn't taking any credit for what he was doing to himself, so I had to. He wasn't in control. I mean, it wasn't anything big, it was just marijuana. He was saying, "Oh, this is fun, it feels good, it helps me forget about my mom who's been a bitch today." And he did it alone, which really bothered me. He didn't even have a reason, just like, "I don't know, it's kind of fun, there's nothing better to do on my Saturday night." And then it got to be, "I'm really addicted to this stuff." I felt completely powerless in the whole thing. I was afraid that he'd dump me, which was stupid because I had the upper hand the whole time and I didn't even know it.

I felt pressure to have sex with my boyfriend, but it was mutual pressure. We were both talking about it for a year and a half before it even came up as a possibility. It was so cute the way we crept up on the subject. "So, what if I asked you if you wanted to possibly, maybe in the future sometime, have sex with me?" I asked. He said, "Yeah, I could see that happening." We tried it a couple of times, but nothing ever happened because we would wimp out and go, "Well, maybe we're not ready." It was great that

we were both fluctuating. And it just ended up not happening. I don't feel like my virginity is something terribly sacred that I'm afraid to lose. However, I have prerequisites, like it's not in the back of some car with some guy. It's got to be meaningful and it's got to be a person I care about.

I don't think of myself as a sexual being, or seductive or erotic, which at times I really want to be because it would be so much fun. I view myself as a bear. I'm a huggable, lovable thing. I don't want to be really skinny. I don't want to be fat, but there's got to be something there. There's always someone who will come around who likes that kind of thing, and even if not, as long as I'm comfortable to do the things I want to do, then I'm okay with that. My build isn't ideal which, of course, no one's is in our society—this style in the nineties of having your chest be almost in line with your hips. My hips are a lot wider, my chest is wide, my butt is wide, and my thighs are wide. So, it's not ideal, not right now. But in Marilyn Monroe's time it was definitely ideal. I admire that times change, at least.

I would say I'm beautiful, because when I use the word "beautiful" I mean a person I could get to know—a person I admire but not someone I want to look like, necessarily. A beautiful person is comfortable with herself, is welcoming in all ways. It's how you carry yourself, not how you walk, but how you view yourself.

I think my best friend is beautiful. She makes potpourri to give to people she likes. She talks very slowly because she takes her time with her words. She doesn't do her homework if she doesn't want to. She will pick lint off of my shirt, she'll lend me clothes. She'll take me outside if I am unhappy and tell me that I should look up at the sky and realize how small I am to that star up there. She's genuine. She shows you the beauties in life. She has cancer, lymphoma. It's not deadly, but she's my age, for crying out loud! What's amazing is that she said to me, "Well, this is

definitely a traumatic experience and this is going to change my life, but I know there's something in it for me."

I want to be surrounded by people who love me. I would like to eliminate all superficialities if I can and go where happiness leads me, no matter what. If you have a goal and you've meditated on it and it seems to be the place you need to go, then go. And don't look back and don't worry about what's going to happen, because it will all turn out just fine.